# IRON FROM TUTANKHAMUN'S TOMB

# IRON FROM TUTANKHAMUN'S TOMB

Katja Broschat, Florian Ströbele, Christian Koeberl,
Christian Eckmann, and Eid Mertah

Translated by Manon Schutz

The American University in Cairo Press
Cairo   New York

Römisch-Germanisches Zentralmuseum
Leibniz-Forschungsinstitut für Archäologie

R|G|Z|M

First published in 2022 by
The American University in Cairo Press
113 Sharia Kasr el Aini, Cairo, Egypt
One Rockefeller Plaza, 10th Floor, New York, NY 10020
www.aucpress.com

Copyright © 2022 by The American University in Cairo Press

This English edition is a revised and updated version of *Himmlisch! Die Eisenobjekte aus dem Grab des Tutanchamun*, which was first published in 2018 by Verlag des Römisch-Germanischen Zentralmuseums Mainz. Translated from the German by Manon Schutz.

All rights reserved. No part of this publication may be reproduced, stored in a retrieval system, or transmitted in any form or by any means, electronic, mechanical, photocopying, recording, or otherwise, without the prior written permission of the publisher.

ISBN 978 1 617 97997 2

Names: Broschat, Katja, author. | Ströbele, Florian, author. | Koeberl,
 Christian, 1959- author. | Eckmann, Christian, author. | Mertah, Eid,
 author. | Schutz, Manon, translator.
Title: Iron from Tutankhamun's tomb / Katja Broschat, Florian Ströbele,
 Christian Koeberl, Christian Eckmann, and Eid Mertah ; translated by
 Manon Schutz.
Identifiers: LCCN 2021016949 | ISBN 9781617979972 (hardback) | ISBN
 9781649030313 (epub) | ISBN 9781649030320 (pdf)
Subjects: LCSH: Tutankhamen, King of Egypt--Tomb. | Iron--Egypt. |
 Ironwork--Egypt. | Art metal-work, Ancient--Egypt. | Meteorites,
 Iron--Egypt. | Grave goods--Egypt. | Egypt--Antiquities.
Classification: LCC DT87.5 .B6913 2021 | DDC 932/.014--dc23

1 2 3 4 5    26 25 24 23 22

Designed by Sally Boylan
Printed in China

# Contents

| | |
|---|---|
| Author biographies | vii |
| List of figures and tables | ix |
| Preface | xiii |
|     Acknowledgments | xiii |
| **1 Heavenly!** | 1 |
| **2 The iron "treasures"—sixteen small chisels** | 5 |
| **3 A protective bracelet for the king** | 9 |
| **4 Laid to rest—a miniature headrest** | 11 |
| **5 Simply the best—the dagger with the iron blade and gold sheath** | 13 |
|     The dagger | 13 |
|     The sheath | 20 |
| **6 Iron in pharaonic times** | 23 |
|     Meteoritic iron . . . | 24 |
|     . . . and its processing | 25 |
| **7 "Iron from the sky" in the tomb of Tutankhamun** | 27 |
|     The chisel tips | 28 |
|     The *wedjat* amulet | 28 |
|     The miniature headrest | 28 |
|     The iron blade of the dagger | 30 |
| **8 What do we know now, 3,300 years later?** | 31 |
| **Appendix: The golden dagger** | 35 |
|     Simply the very best—the golden dagger and sheath | 35 |
|     The golden dagger—"twin" or "elective affinity"? | 47 |
| **Notes** | 49 |
| **Bibliography** | 57 |

# Author biographies

**Katja Broschat** is a conservator at the Römisch-Germanisches Zentralmuseum in Mainz, Germany. Her focus is on technology used in manufacturing objects, especially antique glass and metalwork. She is one of the few people to work on the very delicate Cage Cups from the late Roman period, and early glass in Egypt. She also spent several years in Xi'an, China, restoring and studying polychrome painted life-size bronze birds from the tomb of the First Emperor, Qin Shi Huangdi. Since 2013 she has lived and worked in Egypt, focusing on different artifact types from the tomb of Tutankhamun. She was elected a Corresponding Member of the German Archaeological Institute in 2017.

**Christian Eckmann** is a conservator and Head of the Department for Restoration and Conservation and Deputy Director General at the Römisch-Germanisches Zentralmuseum in Mainz. His focus is on the technologies used in manufacturing objects, especially antique metalwork. He has restored precious finds from the famous tomb of the Lord of Sipán, Huraca Rajada, Peru and has carried out comprehensive research on the different techniques of gilding during the Moche Period. He also carried out a multi-annual project to restore and study the manufacture of the oldest life-size copper statues of Pepi I in the Egyptian Museum in Cairo. He has spent several years in Xi'an, restoring and studying polychrome painted life-size bronze birds from the tomb of the First Emperor, Qin Shi Huangdi, and since 2013 he has lived and worked in Egypt, focusing on different artifact types from the tomb of Tutankhamun. He was elected a Corresponding Member of the German Archaeological Institute in 2017.

**Christian Koeberl** is a Professor of Impact Research and Planetary Geology at the University of Vienna, was Director General of the Natural History Museum in Vienna, and is a full member of the Austrian Academy of Sciences. His main research interests are focused on meteorites and meteorite impacts, as well as isotope geochemistry and the study of the Moon, Mars, and the early Earth; he has published more than 500 peer-reviewed scientific papers, and has had an asteroid named in his honor.

**Eid Mertah** is a conservator of archaeological materials in the Restoration and Conservation Department of the Egyptian Museum, Cairo. He studied conservation at Cairo University, where he is currently completing his PhD, focusing on polychrome bronze statues of Osiris of the first millennium BC. He has participated in various archaeological projects in Egypt. His working experience includes internships at the National Museum in Beijing, the Römisch-Germanisches Zentralmuseum, Mainz and Ca' Foscari University, Venice.

**Florian Ströbele** holds a PhD in Geochemistry/Archaeological Sciences. Between 2011 and 2019 he was a researcher at the archaeometry laboratories of the Römisch-Germanisches Zentralmuseum, Mainz and of Historic England, Portsmouth, UK. The main focus of his work is the chemical analysis of archaeological materials—predominantly metals, but he also has some experience in other materials and the application of isotopes for provenance studies.

# List of figures and tables

All photographs by Ch. Eckmann, RGZM, unless otherwise credited.

Fig. 1 Howard Carter and George Herbert, Fifth Earl of Carnarvon. (Archives du Palais Royal, Brussels)

Fig. 2 The golden mask of Tutankhamun (EMC, JE 60672).

Fig. 3 Funerary procession depicted in a wall painting from the tomb of Ramose (No. TT 55) at Thebes. (After Davies 1936, pl. LXXIII)

Fig. 4 Six chisels with iron tips: excavation photograph by Harry Burton. (Photograph by H. Burton (p1052), © Griffith Institute, University of Oxford)

Fig. 5 Chisel with iron tip, original size (EMC, JE 61304).

Fig. 6 Graphic illustration of sixteen chisels with iron tip (EMC, JE 61295–61310). (Illustration by M. Ober, RGZM)

Fig. 7 Gold armring/bangle with a *wedjat* amulet made of iron (EMC, JE 62385).

Fig. 8a Close-up of surface detail of the *wedjat* amulet.

Fig. 8b Close-up of surface detail of the *wedjat* amulet.

Fig. 8c Close-up of surface detail of the *wedjat* amulet.

Fig. 8d Close-up of surface detail of the *wedjat* amulet.

Fig. 9a View a (right eye) of the *wedjat* amulet.

Fig. 9b View b (left eye) of the *wedjat* amulet.

Fig. 10 Photograph of the armring/bracelet with iron amulet in situ on the mummy of Tutankhamun, plus detail; excavation photograph by Harry Burton. (Photograph by H. Burton (p0783), © Griffith Institute, University of Oxford)

Fig. 11 Headrest *(weres)* amulet (EMC, JE 61869).

Fig. 12a Joint of a separate piece of iron attached to the headrest amulet.

Fig. 12b Detail of the joint of a separate piece of iron attached to the headrest amulet.

Fig. 13a Disrupted surface structure on the base of the headrest amulet.

Fig. 13b Detail of the disrupted surface structure on the base of the headrest amulet.

Fig. 14 Detail of the column of the headrest amulet.

Fig. 15 The dagger with the iron blade in situ on the mummy of Tutankhamun, and detail; excavation photograph by Harry Burton. (Photograph by H. Burton (p1567), © Griffith Institute, University of Oxford)

Fig. 16 Shield from the tomb of Tutankhamun showing a bull's tail attached to his back; excavation photograph by Harry Burton (EMC, JE 61576). (Photograph by H. Burton (p1201), © Griffith Institute, University of Oxford)

Fig. 17a Full view of one side of the dagger with the iron blade (EMC, JE 61585).

Fig. 17b Full view of the other side of the dagger with the iron blade.

Fig. 18 Close-up of a small gold pin that fixes the pommel onto the dagger with the iron blade.

Fig. 19a X-ray of the dagger with the iron blade, side view. (X-ray image by S. Manaa)

Fig. 19b X-ray of the dagger with the iron blade, front view. (X-ray image by S. Manaa)

Fig. 19c Drawings (front and side view) of the iron blade with its tang. (Drawings by M. Ober, RGZM)

Fig. 20a Rock-crystal pommel of the dagger with the iron blade, side view.

Fig. 20b Rock-crystal pommel of the dagger with the iron blade, view from top.

Fig. 21 Detail of the joint of the cylindrical gold sheet on the handle of the dagger with the iron blade.

Fig. 22a Detail of the handle of the dagger with the iron blade.

Fig. 22b Life-size drawing of the handle of the dagger with the iron blade by Howard Carter. (Drawing by H. Carter (TAA Archive i.1.256k.3), © Griffith Institute, University of Oxford)

Fig. 23 Detail of red inlays inserted with pigmented material on the handle of the dagger with the iron blade.

Fig. 24 Detail of the surface of the iron blade from the dagger.

Fig. 25 Detail of the interface from the handle toward the blade of the dagger.

Fig. 26a Sheath belonging to the dagger with the iron blade (front view).

Fig. 26b Sheath belonging to the dagger with the iron blade (reverse view).

Fig. 27a Photograph of the golden dagger in situ by Harry Burton (EMC, JE 61584). (Photograph by H. Burton (p780), © Griffith Institute, University of Oxford)

Fig. 27b Drawing of the golden dagger in situ by Howard Carter. (Drawing by H. Carter (TAA Archive i.4.12), © Griffith Institute, University of Oxford)

Fig. 28 Photograph of the golden dagger of Tutankhamun.

Fig. 29a Detail of the pommel of the golden dagger (front view).

Fig. 29b Detail of the pommel of the golden dagger, side view.

Fig. 30a Near infrared image of the pommel of the golden dagger, front view.

Fig. 30b Near infrared image of the pommel of the golden dagger, the reverse side.

Fig. 30c Reconstruction of the motif from the pommel of the golden dagger, front view. (Reconstruction by M. Ober, RGZM)

Fig. 30d Reconstruction of the motif from the pommel of the golden dagger, side view. (Reconstruction by M. Ober, RGZM)

Fig. 30e Alternative reconstruction of the motif from the pommel of the golden dagger, side view. (Reconstruction by M. Ober, RGZM)

Fig. 31a Pommel plate of the golden dagger.

Fig. 31b Reconstruction of the motif from the pommel plate of the golden dagger. (Reconstruction by M. Ober, RGZM)

Fig. 31c Alternative reconstruction of the motif from the pommel plate of the golden dagger. (Reconstruction by M. Ober, RGZM)

Fig. 32 Full view of the handle of the golden dagger, side view.

Fig. 33 Detail of the granulation decoration on the handle of the golden dagger.

Fig. 34 Detail of a lotus/lily motif from the handle of the golden dagger.

Fig. 35 Detail of wire work from the handle of the golden dagger.

Fig. 36 Detail of a filigree band from the handle of the golden dagger.

Fig. 37 Detail of the surface of the gold blade of the dagger.

Fig. 38 X-ray of the dagger with the gold blade, front view. (X-ray image by S. Manaa)

Fig. 39 Detail of the sheath of the golden dagger.

Fig. 40 Detail of solder joints on the sheath belonging to the golden dagger.

Fig. 41 Detail of the colorful inlaid feather or scale pattern on the sheath belonging to the golden dagger.

Fig. 42a Detail of the decorated tip of the sheath belonging to the golden dagger.

Fig. 42b Detail of the decorated tip of the sheath belonging to the dagger with the iron blade.

Fig. 43 Detail of the animal combat scene on the sheath belonging to the golden dagger.

Fig. 44a Full view of the sheath belonging to the golden dagger, front.

Fig. 44b Full view of the sheath belonging to the golden dagger, back.

Fig. 45a Detail of the inlaid decoration on the handle of the dagger with the iron blade.

Fig. 45b Detail of the inlaid decoration on the handle of the golden dagger.

Fig. 46a Detail of the granulation work on the handle of the dagger with the iron blade.

Fig. 46b Detail of the granulation work on the handle of the golden dagger.

Table 1 The composition of meteorites that were used in the calculation of the calibration curve used for the analysis of the iron objects from the tomb. (Table by F. Ströbele)

Table 2 Results of the qualitative analysis of the sixteen chisels with iron tips. (Table by F. Ströbele)

Table 3 Results of the analysis of the dagger blade, the small headrest, and the *wedjat* amulet. (Table by F. Ströbele)

Unnumbered illustrations:
Page xii Detail of Fig. 43b.
Page 56 Photograph of the two daggers by Harry Burton. (Photograph by H. Burton (p869), © Griffith Institute, University of Oxford).
Page 62 Detail of palmette on the blade of the golden dagger.

Chapter 7 photographs:
Page 28 (left) An iron chisel.
Page 28 (right) Repeat of Fig. 9a.
Page 29 The headrest amulet.
Page 30 Detail of Fig. 17b.

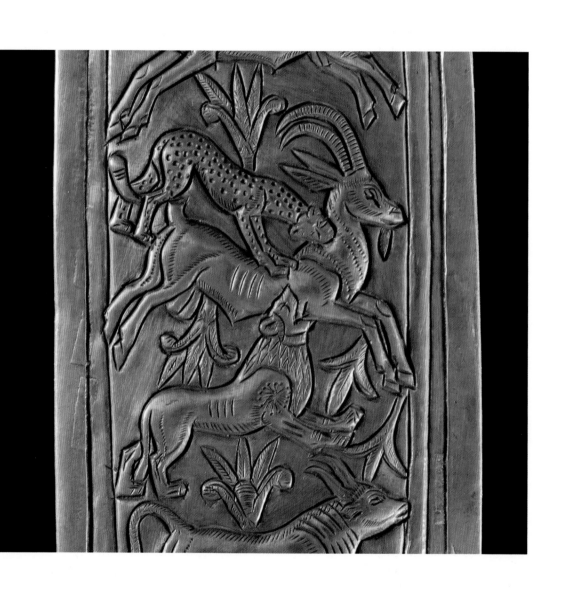

# Preface

It might be surprising that there are still finds from the legendary tomb of Tutankhamun that, since their discovery by Howard Carter in 1922, have not yet been presented to the public. One such group of finds that so far has been largely neglected consists of the approximately one hundred leather pieces elaborately decorated with gold sheets that were kept in the storeroom of the Egyptian Museum in Cairo due to their poor state of preservation. From 2014 to 2017, a cooperative project was launched between the Egyptian Museum in Cairo (EMC) and the Römisch-Germanisches Zentralmuseum (RGZM) in Mainz at the initiative of the Deutsches Archäologisches Institut Kairo (DAIK, German Archaeological Institute, Cairo division) and the Institut für die Kulturen des Alten Orients (IANES, Institute for the Cultures of the Ancient Orient) of the Eberhard Karls University in Tübingen. Its aim was to carry out an archaeological iconographic, material, and archaeometric investigation of the objects, as well as a full documentation and restoration of these unique artifacts.

These objects, found in close proximity to the chariots from the tomb, represent the remains of horse harnesses and weapon paraphernalia, and can be identified, based on rarely preserved parallels, as the decorative fittings of bow cases, quivers, and horse bridles. What could be more appropriate than studying and analyzing the surviving examples of such objects from the tomb as well? In the course of this, bundles of arrows, a quiver, an elaborately decorated bow case, and two splendidly ornate daggers from the burial equipment also found their way into the restoration laboratories of the Egyptian Museum in Cairo.

One of these two daggers has always sparked particular interest because it has a perfectly manufactured, well-preserved iron blade. Iron was a highly unusual, as well as an exclusive and exotic, material at the time of Tutankhamun. Carter was intrigued to find even more iron objects in the tomb! These iron objects have never been studied as a group before, which led to our focusing on them in our work. This book shows how even well-known finds can yield more information upon careful reexamination.

## Acknowledgments

It was possible to investigate this group of finds thanks to the kind permission of the Egyptian Ministry of Antiquities (now Ministry of Tourism and Antiquities) in particular, but first and foremost also to the Egyptian Museum in Cairo, where most of them were housed at the time. Special thanks are due to the museum director, Sabah Abdel Razek, and to Hala Hassan, the curator of Section I, who have always supported and facilitated our work with grace and collegiality. Tutankhamun's objects will ultimately all be housed at the Grand Egyptian Museum (GEM) at Giza. Some of the iron objects have already moved to storage at the GEM and we thank its staff for their cooperation in granting us access.

The authors are particularly grateful to Jutta Zipfel for selecting well-studied iron meteorites from the collection of the Senckenberg Research Institute and Natural History Museum (Frankfurt am Main), which were made available for calibrating the measuring device, as well as for her contribution to the discussion of the analytical data. We are also indebted to the curators of the meteorite collection of the Natural History Museum Vienna for additional calibration samples.

Furthermore, we would like to extend our very deep and personal gratitude to Andreas Effland, Salima Ikram, Tom Hardwick, and Thilo Rehren for their critical review and valuable suggestions for the improvement of the manuscript. Also to Julia Bertsch for an interesting discussion about 'lilies,' volute-like plants, and palmettes—the forthcoming publication of her dissertation will help to differentiate and interpret the motif group in the decoration

of the daggers more accurately, a topic from which we were obliged to abstain in this contribution due to its scope. Lee Drake kindly assisted in the creation of the calibration and Sabri Manaa was responsible for the generation of the X-ray images.

Without the patience and expertise of the editorial staff of the American University in Cairo Press, and of the RGZM, including the designer of the German edition, Claudia Nickel, this book would not have come to fruition. Thanks are due to Michael Ober for the excellent graphics with which he has enriched this publication. Figures that are interesting and essential for the explanation of the text could not have been shown here without collegial support from the Griffith Institute of the University of Oxford and the Archives du Palais Royal in Brussels. We sincerely thank these institutes for their generous permission to publish them.

# 1 Heavenly!

On a November day in the year 1922, a reverential hush descended on a group of archaeologists in the Valley of the Kings on the west bank of modern Luxor, when they finally stood in front of a doorway blocked and sealed with Tutankhamun's cartouches. Howard Carter and his team were about to bestow on the world the first nearly intact tomb of an ancient Egyptian king (Fig. 1)!

Without the "discovery of the century," the youthful pharaoh would probably have been known merely to scholars. Nobody could ever have imagined his breathtaking treasures and burial equipment of gold and precious stones, produced with the cutting-edge technology of his time.

Tutankhamun reigned for approximately nine years (about 1332–23 BC) at the end of the Eighteenth

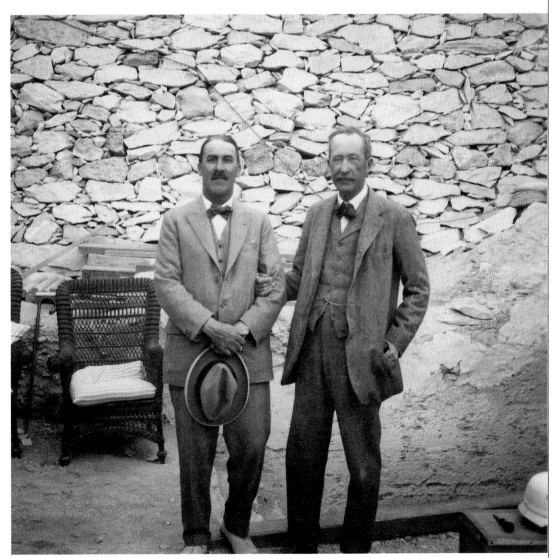

**Fig. 1** With slickly brilliantined hair and hat in hand: Howard Carter (left) and his friend and patron George Herbert, Fifth Earl of Carnarvon, in front of the steps leading to the tomb of Tutankhamun in the Valley of the Kings. By discovering this tomb in 1922, the two became legends themselves.

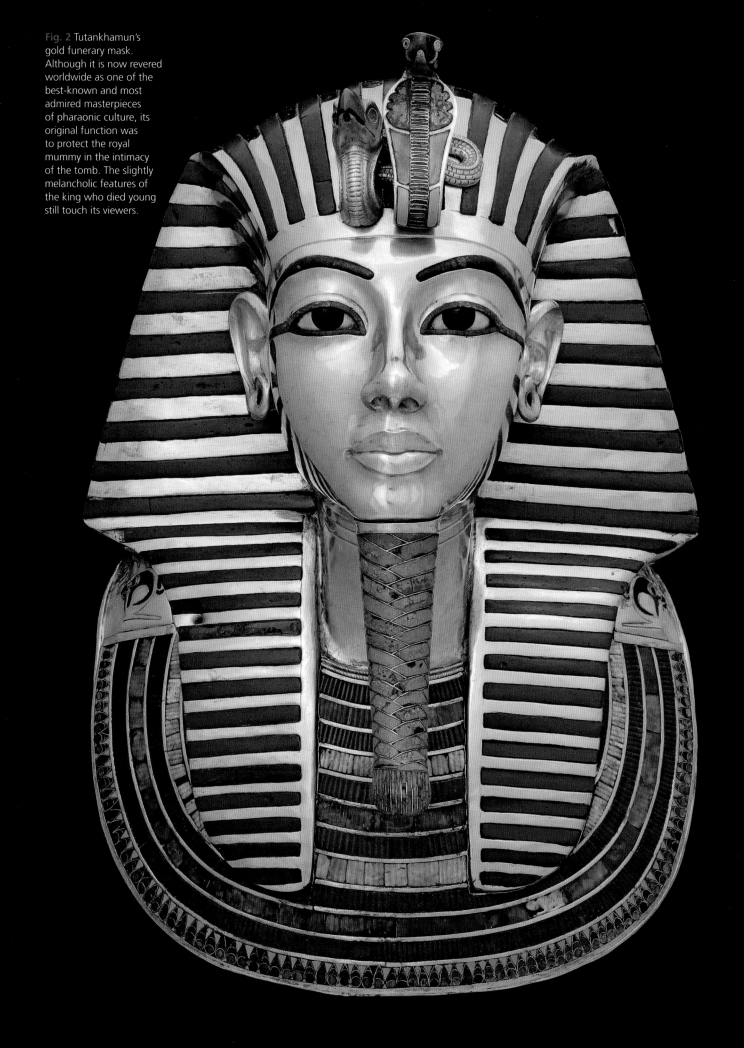

Fig. 2 Tutankhamun's gold funerary mask. Although it is now revered worldwide as one of the best-known and most admired masterpieces of pharaonic culture, its original function was to protect the royal mummy in the intimacy of the tomb. The slightly melancholic features of the king who died young still touch its viewers.

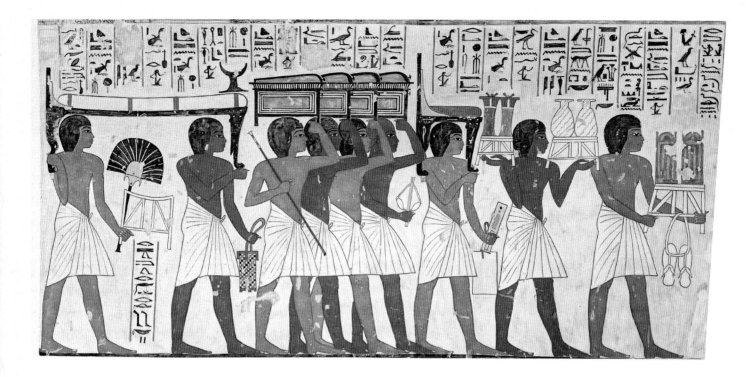

Fig. 3 Wall painting depicting a funerary procession in the tomb of Ramose (Eighteenth Dynasty, Theban Tomb 55), Western Thebes.

Dynasty of Egypt's New Kingdom (about 1570–1070 BC). His ancestors dominated great parts of the ancient Near East, controlling land from modern-day Syria to Sudan. The "Great Kings" of Egypt, Mitanni (Northern Syria), and of the Hittites (in Asia Minor, modern Turkey) lived in a time of opulence and technical innovations, exchanging tokens of mutual esteem. These included slaves, horses, textiles, and the high-status objects and high-tech materials of the late Bronze Age: chariots, weapons, glass, and gold and other valuable metals.

When Tutankhamun ascended the throne, he was a boy of about nine years, called Tutankhaten—his name honoring the divine sun-disk, the Aten. His probable father, King Akhenaten, had initiated what Egyptologists call the Amarna period, replacing the chief god Amun with the Aten, and declaring himself the living embodiment of the Aten. He moved the capital from Thebes (modern Luxor) to further north, founding a new city that he called Akhetaten ("the Horizon of the Aten," modern al-Amarna). When Tutankhaten became king, he and his advisors swiftly reversed Akhenaten's reforms, moving the capital back to Thebes, and restoring the old cults—the major achievement of his nine-year reign. Marking the return of the status quo, he changed his name to Tutankhamun. Despite this, his successors removed most of his names from his monuments, replacing them with their own, and thus almost erased him from history. Shortly after his burial, his tomb was partially robbed and resealed, being covered and forgotten until its discovery in 1922.

However, the excavation of this teenage minor king's 3,300-year-old tomb precipitated an outburst of "Tutmania" in the 1920s. Its astonishing contents influenced fashion, design, art, and culture. They fascinated scientists, children, journalists, and heads of state as well as millions of visitors to his tomb and the Egyptian Museum in Cairo, where the contents of his tomb were housed. Tutankhamun's gold funerary mask, one of the best-known and revered archaeological icons in the world, represents a masterpiece of the ancient art of goldsmithing (Fig. 2).

But what else did a pharaoh of the Eighteenth Dynasty need for his journey to the afterlife? Information regarding this question is provided, among other sources, by funerary texts (generally called "Books of the Dead" by Egyptologists),[1] as well as by depictions of funerary processions[2] and tomb inventories of the New Kingdom (Fig. 3). Indispensable items included clothes, jewelry, toiletries, writing equipment, weapons, furniture, containers, games, lamps, and food and drink—in a nutshell, all the things that the king needed

during his lifetime. These were complemented by goods that were intended exclusively for the burial, such as—besides the funerary mask—coffins, shrines, divine images, so-called *shabti* figures that worked for the dead person in the underworld, protective magical amulets, and tools and objects that were essential for the performance of ritual activities.

About 5,400 objects accompanied Tutankhamun on his last journey, and represent the largest surviving set of pharaonic burial equipment. Although it appears particularly lavish to us nowadays, it cannot be known how it would have compared with the (now lost) burial goods of far more prominent pharaohs. But still, an immense amount of gold! For almost a century, this precious metal has blinded its beholders and outshone some of the tomb's other treasures.

Along with these numerous objects made of gold, silver, electrum (an alloy of gold and silver which both occurs naturally and can be man-made), and bronze, a small group of iron objects survived from Tutankhamun's tomb. These iron objects have always aroused particular interest as they stem from a time when Egyptians were still far from being aware of, let alone using, the technology of iron smelting.

Altogether Carter recovered nineteen objects made from iron: a wooden chest (Carter no. 316)[3] yielded sixteen small iron tools set into wooden handles (Carter no. 316a–p); a small iron amulet in the form of an "Eye of Horus" *(wedjat)*[4] attached to a gold bracelet (Carter no. 256,hh[2]); another small amulet in the shape of a miniature headrest (Carter no. 256,4,v); and a dagger. This dagger, which is lavishly adorned with gold and inlays of stone and glass, has an iron blade and is one of Tutankhamun's most famous burial goods (Carter no. 256k). With the exception of the iron tools, which were deposited in the "treasury" of the tomb, all the other iron artifacts were found within the mummy wrappings: clearly, these iron objects were not only rare, but highly appreciated and possessed significant meaning.

# 2 | The iron "treasures"—sixteen small chisels

. . . I should here add, that with the exception of the king's dagger all examples of iron in this tomb show distinct crudeness in their workmanship. (Carter 1933, 93)

The simple wooden chest that contained the iron tools was located in the so-called treasury of the tomb. It had already been broken into and robbed in antiquity, and contained no other objects.[5] Some of the chisel tips had become detached from their coniferous wood handles;[6] one of them lay on the floor in front of the chest (Carter 1933, 89). The object card reads, "The blades of these model tools are approx. 1/2 mm in thickness and are coated with rust" (Fig. 4). It cannot be discerned whether the iron tips are corroded completely or only superficially.[7]

There are various views on the original function of these chisels: G.A. Wainwright (1932, 7), for instance, interpreted them as ritual tools and placed them into the context of the Opening of the Mouth ritual, an essential act of renewal, revival, and resurrection. It was probably performed on a subsidiary statue as well as in an abbreviated form on the mummy itself during the burial rites.[8] In the Pyramid Texts, royal funerary rituals of the Old Kingdom (c. 2345–2200 BC), these tools are said to be made of *bia* (iron?), but so far there is no archaeological evidence for smelted iron from Egypt at this time.[9]

Tools for the Opening of the Mouth ritual exist from the Old Kingdom onward, and more elaborate representations of them appear in New Kingdom tombs. They consist of small steep-walled cups and

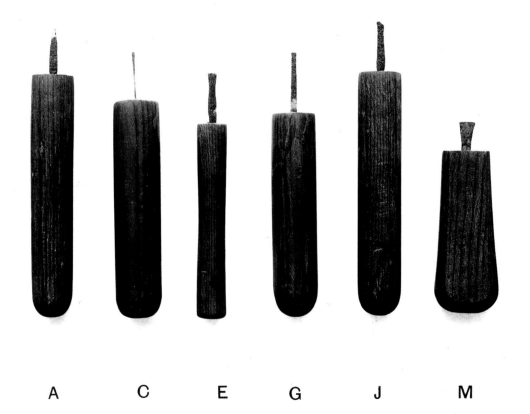

**Fig. 4** Another colleague of Carter's, the photographer Harry Burton of the Metropolitan Museum in New York, was seconded from the museum in order to assist the team in the Valley of the Kings. He photographed a representative selection of six of the sixteen delicate tools. Scale 1:2.

**Fig. 5** One of the sixteen chisels, with a seemingly unused handle made of coniferous wood. Scale approx. 1:1.

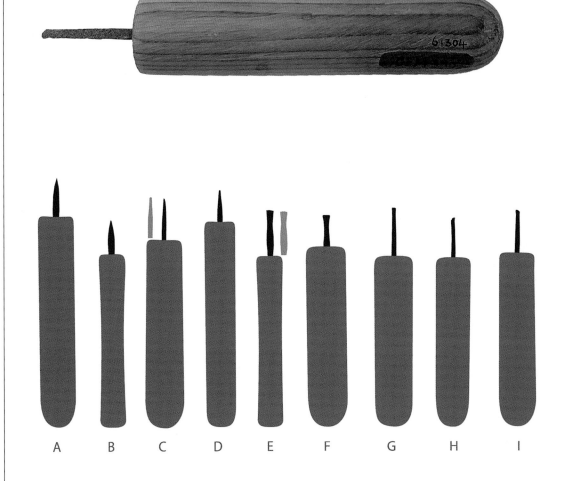

**Fig. 6** The chisel tips, as well as the handle pieces, vary in form and thus seem to have been produced for specific tasks. "A & B are lance-shaped; C & D are twisted at the point into graver form; E & F are chisel form with slight waist; G, H & I are straight chisel form; J, K, H are similar to E and F, Round handles; M, N, O, P are short broad chisel types—their handles are flat" (Card/Transcription no. 316-3). The chisels at C, E, and J were drawn from Burton's photograph (Fig. 4), which did not show a full view of the tips. For better comparison, corrected versions of the tips are also added. Original illustration reduced.

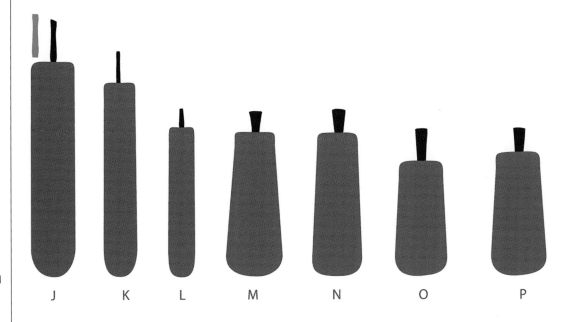

6   The iron "treasures"—sixteen small chisels

small jugs—made of white and black stones—for magical substances, a fishtail-knife *(pesesh-kef)*, and several blades, whose name, *netjeri*, invokes the divinity that the dead person would achieve through the performance of the ritual. A set could also include implements in the form of adzes, fingers, an arm-shaped incense burner, and a (magic) wand with a ram or snake head. In the context of the Opening of the Mouth ritual, only a few depictions show chisels similar in form to Tutankhamun's, two well-published examples being the Theban tombs of Rekhmire (No. TT 100) and the sculptor Ipuy (No. TT 217; for both, see Otto 1960). However, if these representations are true to scale in relation to the rest of the scene, the tools are notably larger in size than those of Tutankhamun. Carter disagreed with Wainwright's classification of these as ritual instruments. He understood them as model tools that were placed in the treasury only because of their unusual material (Carter 1933, 90).

The handles look astonishingly new and unused; there are virtually no traces of abrasion or staining on them (Fig. 5). Alfred Lucas, the Egyptian Antiquities Service's chemist, who was seconded to Carter's team and analyzed and restored many of the objects from the tomb, wrote that he only needed to clean the handles with a damp sponge after their excavation.[10] The different shapes of the handles, implying that they were held and used in different ways, in combination with the variety of chisel sizes and tips leads us to conclude that these objects are not model instruments but rather operational precision tools (Fig. 6).[11]

Were the chisels incorporated into the tomb inventory just because of their unusual material, or were they used in a practical or ritual context, for instance, for the fabrication of the substitute statue? There is insufficient evidence to come to any conclusions about their purpose.

**Fig. 7** Gold bracelet with an iron amulet in the shape of a *wedjat*-eye; W. 7.6 cm.

# 3 A protective bracelet for the king

Three bangles were found within the king's mummy wrappings on the right side of the ribcage. Among these is a crescent-shaped hollow bangle that is completed by a small *wedjat*-eye amulet (Carter no. 256hh), made of sheet iron (Fig. 7).

The *wedjat*-eye (alternatively written *udjat*—Carter himself used both), commonly called the Eye of Horus, is one of the most popular protective amulets of ancient Egypt, and is immediately recognizable from its lines extending the eyebrow and the corner of the eye, and under the eye, toward the cheek, mimicking the feather pattern of raptors who are associated with the god Horus. The left eye is associated with lunar aspects of the gods Horus or Thoth, while the right eye is associated with the solar aspects of Horus or Re.[12] However, these distinctions are often blurred, both by the ancient Egyptians and Egyptologists.

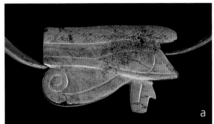
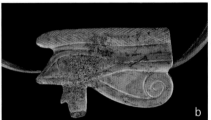

Besides their use as amulets, *wedjat*-eyes were the symbol par excellence of offerings (Rudnitzky 1956) and appear frequently as a motif in the decoration of coffins and other burial equipment in the New Kingdom (Bonnet 1952, 314–15; 854–56). Bracelets combined with a *wedjat* amulet are an innovation of the New Kingdom, and several of these protected Tutankhamun's mummy. As the first known (and thus far, only) New Kingdom example made of iron, this one is even more special.

**Fig. 9** Alternative ways of wearing the amulet: either as the proper right (a) or the left eye (b); approx. 2.1 cm x 3.5 cm (H. x W.).

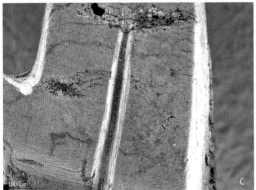
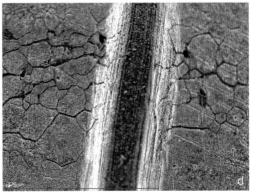

**Fig. 8** The surface of the amulet seems slightly unusual: besides traces of grinding and filing (a), its matt and rough finish occasionally shows vesicular porous or foam-like structures (b) as well as cavities and cracks (c–d). These imperfections could represent areas in which the iron ingot once contained silicate inclusions that subsequently became detached during the work process (for example, during hammering), or else corrosion patterns that led to a similar result. In some areas, the grain boundaries of the crystals are visible on the surface—probably the result of intergranular corrosion processes.

The amulet is manufactured from a single sheet of metal that was decorated with two eyes depicted back-to-back, then folded between the eyebrows to produce an eye (one left, one right)[13] on each face. The depictions of the eyes were worked in raised relief, by chasing the sheet from behind (repoussé[14]), with subsequent decoration added on the surface by filing[15] fine lines and polishing. The eyebrows are adorned on both sides with a herringbone pattern. The outer edges of the sheet are bent inward at a ninety-degree angle, and were originally meant to touch each other. However, these edges are now slightly distorted and no longer fit precisely together. Lucas studied and treated the object, and noted that it "had several large patches of dark red corrosion looking like rust. This gave a yellow solution with HCl which gave a blue coloration with potassium ferrocyanide … . Cleaned with fine dust + caustic soda (hot). Washed well + coated with Vaseline." (Fig. 8a–d).[16] Above the inner corner of the eye and also on the far end of the cosmetic line, the metal is slightly bent open in order to accommodate the tapering ends of the bracelet. This allowed the amulet to rotate freely so it could be worn as a right or a left eye (Fig. 9a and b, see note 13).

Strictly speaking, the *wedjat* only represents the left eye of Horus, whereas the right eye actually symbolizes the eye of Re. Nevertheless, possibly due to their preference for the right, auspicious side (that of the sun) over the left, the Egyptians, from early times onward, favored representations of the right eye (Bonnet 1954, 855). As placed on the mummy, the iron amulet functions as a right eye "looking" toward the dead king's face and the West (Fig. 10).

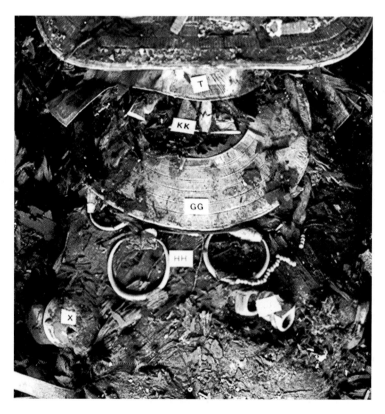

**Fig. 10** Detail of an in situ photograph from 1925: the bracelet lies on the right side of the ribcage with the eye as a right eye "looking" toward the West.

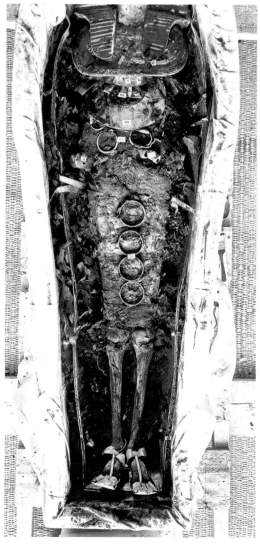

# 4 | Laid to rest— a miniature headrest

A small iron amulet in the form of a headrest *(weres)* was positioned under the neck of the deceased king. Carter's notes on it vary slightly. In his journal he wrote: "Besides a small amuletic headrest (4.V.), found beneath the above mentioned head pad. . .", while the object card states, "Beneath head of king—lying on back (interior) of mask."[17] Regardless, these two statements indicate that the amulet was not wrapped within the bandages, but placed between the wrapped head of the king and his funerary mask.[18]

Usually, miniature headrests were placed within the wrappings in the neck and head area. Funerary prayers attribute a specific function to each amulet, and sometimes even specify their material and position on the body to achieve their full effect. As the practice of equipping the deceased with small headrest amulets was only established in the New Kingdom, it is possible that it was not yet common to place these within the mummy bandages in this early phase of the tradition. An apotropaic function was assigned to headrests in the burial context, where they were supposed to assist the deceased in "getting up," that is, in rising from the dead, and to prevent him from losing his head (both physically and in the afterlife).

Headrest amulets are generally made of hematite, a dark, shiny iron oxide mineral,[19] but, as with the *wedjat* amulet, this is the first iron headrest amulet known from ancient Egypt (Müller-Winkler 1987, 328). Carter described the headrest amulet as consisting "of beaten iron. Very badly made; one branch broken and soldered; the base showing many flaws owing to bad welding"[20] (Fig. 11).

**Fig. 11** The small headrest is made as a single pillar type or Type II-1 according to Reisner's classification (1923, 229–41) (approx. 5 cm x 4 cm [W. x H.]). This picture is enlarged about three times from life size; on the left, the separately worked fragment that was attached to the top is clearly recognizable.

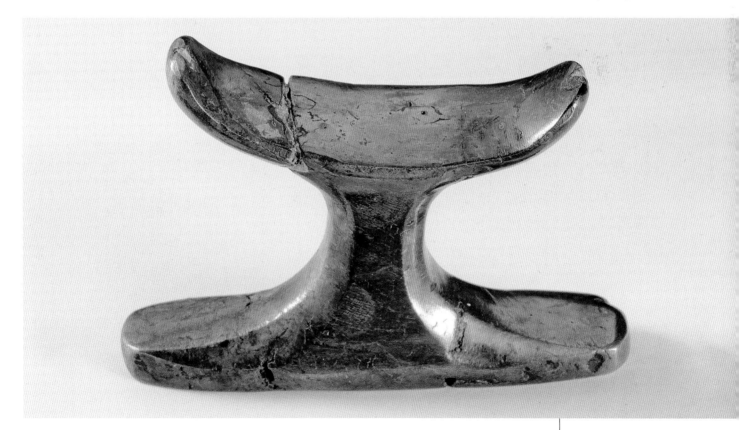

**Fig. 12** (a) Connecting joint on the crescent-shaped top part. (b) Close-up of the soldered joint, which was additionally concealed with a mineral mass and reveals slightly beveled edges.

**Fig. 13** (a) On the foot of the object, disturbed structures are visible on the surface of the metal. The elongated elements are most likely grain boundaries, and represent iron phases with different carbon and phosphorus contents. It is possible that they became detached through weathering processes. If so, these structures would represent still unprocessed areas of the actual surface of the ingot. In addition, toolmarks caused by filing and grinding are discernable only in the adjacent areas. (b) Enlarged section of Fig. 13a.

**Fig 14** The surfaces of the octagonal column are evenly and finely executed.

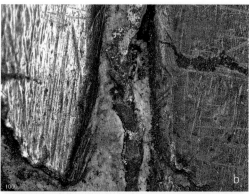
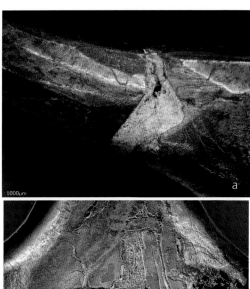
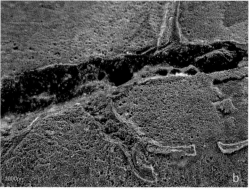
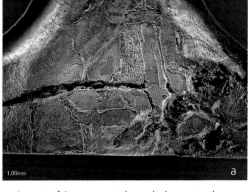
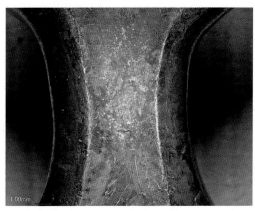

A part of its crescent-shaped element—the area that would have supported the head of the sleeper were it a life-size example of a headrest—was soldered to the main body. The edges of these two parts are slightly beveled, but do not join perfectly. The remaining gap was filled with a granular whitish-gray mineral mass, the color of which was adapted to that of the object (Fig. 12a and b). The question of whether this piece had broken off and been reattached, or whether the amulet was made from two different pieces of the same material for want of a sufficiently large piece of iron, remains open. However, there is little doubt that the two parts were assembled during the production process (or immediately thereafter). In the area of the foot, there are many disruptions in the structure of the raw material consisting of differently sized cavities and cracks, which were not subsequently treated or retouched (Fig. 13a and b).

At first glance, the small headrest appears rather crude compared with the other iron objects from the tomb, due to its slightly bulky form and the irregularity of its surface treatment. Carter commented at the time on the quality of the artifact's manufacture: "From the extremely rough workmanship of this little amulet of iron, it would appear that the ancient artisan was not accustomed to work the metal."[21]

However, closer inspection puts these seeming production flaws into perspective. The headrest is, overall, symmetrical and it is only the varying thickness of the foot that causes the object to stand slightly tilted. This imbalance could be connected to the porous material structure in the foot area, which might not have allowed any further removal of iron from the base.[22] The upper part is well-balanced and crescent-shaped, whereas the column is octagonally formed, with its facets continuing gracefully onto the base—a form that echoes most of the actual headrests found in the tomb (Carter nos. 21c, 101o, 403a, 403b, 547d, 548a). In general, the surface has been finely smoothed and polished (Fig. 14).

# 5 | Simply the best—the dagger with the iron blade and gold sheath

## The dagger

Two daggers were wrapped in different layers of the young pharaoh's mummy bandages. Both are (nearly) identically splendid with their richly decorated handles, enhanced by gold granulation as well as colorful stone and glass inlays.[23] However, the dagger we discuss here differs from the other (see Appendix) not only in its elaborately crafted pommel, made of rock crystal, but also in its almost perfectly symmetrical, bright, and highly polished iron blade.

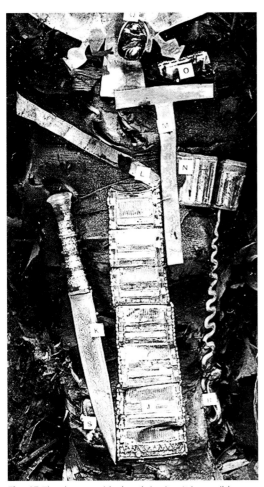

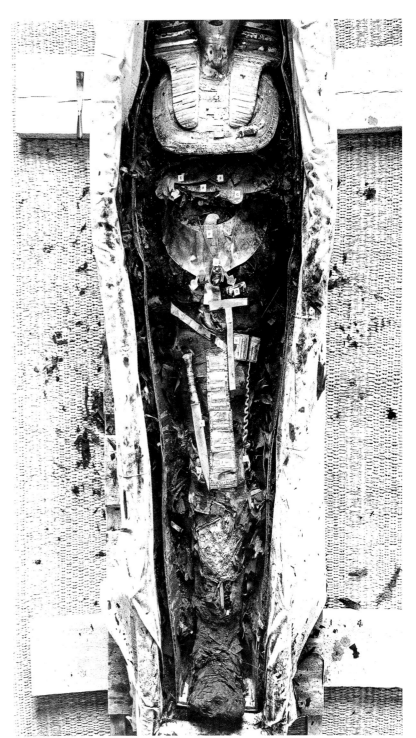

**Fig. 15** The dagger with sheath in situ. It is possible that it was originally attached to the belt.

13

**Fig. 16** Tutankhamun smiting a lion (depiction on a shield [Carter no. 379b]). In this case, the bull's tail attached to his back nearly reaches the king's so-called falcon waistcoat.

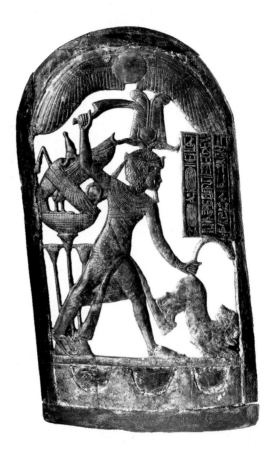

As part of the mummy's equipment, it was placed on the king's right thigh, the pommel level with his pubis and the blade pointing toward the knee (Fig. 15). The dagger was deliberately placed in relation to surrounding objects. A gold apron[24] decorated with colored stone and glass inlays (Carter no. 256j) was purposefully positioned as it would have been worn in life, on the king's thighs, adjacent to the dagger. The two detachable insignia of Tutankhamun's diadem (Carter no. 256,4o), were found flanking the apron: the cobra *(uraeus)*, symbol of Lower Egypt, above the left knee; the vulture head, symbol of Upper Egypt, above the right, both "being placed in correct orientation in accordance to the [part of the] country to which they belong" (Carter 1927, 136).[25] The point of the dagger rested on the vulture head. Carter also connected the dagger with one of the two gold-sheet belts that were found within the mummy bandages,[26] which was essentially used for the attachment of one of the two bulls' tails (Carter 1927, 134),[27] symbols of kingship (Fig. 16), found under the king's body.[28]

In her study of Egyptian daggers, Susanne Petschel attributed this dagger to Type VII of her typology, which is characterized by daggers of composite construction[29] (Fig. 17a and b).

Apart from the iron blade, the elegant rock-crystal pommel particularly stands out. Rock crystal occurs in Egypt's Western Desert and the Sinai, and was elaborately carved into beads, amulets, inlays, small bowls, and figures by the ancient Egyptians.[30] The pommel was attached to a cylindrical wooden tenon, covered in gold foil, by means of gold pins (Fig. 18).[31] This tenon sits atop the hilt, which accommodates the tang of the blade. The tang's flattened upper part has a hole through which a small metal dowel passes to attach it to the hilt (Fig. 19a–c). The rock-crystal pommel is shaped to almost symmetrical perfection. Its upper surface is slightly convex, while its sides are concave, tapering toward the bottom to form a cavetto curve.[32] Both the drilled opening on the inside, which was made to receive the tenon of the hilt, and the four lateral bore holes, which are used to fix the pommel to the tenon, are executed precisely, as slightly conical, and without any noticeable offset (Fig. 20a and b).

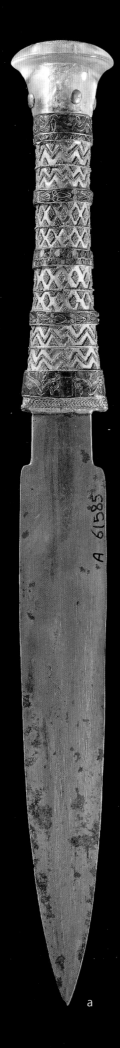
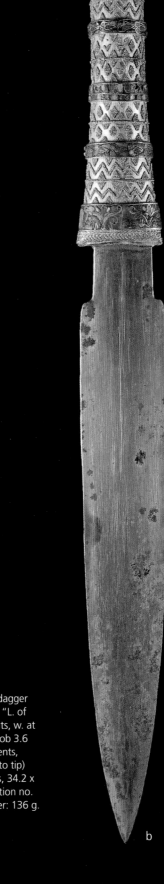

Fig. 17 The two sides of the dagger with the iron blade (a and b): "L. of haft, including knob 13.0 cents, w. at base 3.0 cents, max. w. of knob 3.6 cents, max. w. of blade 3.1 cents, L. of blade (from end of haft to tip) 21.2 cents, total L. 34.2 cents, 34.2 x max. 3.6 cm" (Card/Transcription no. 256k-3). Weight of the dagger: 136 g.

**Fig. 18** The small gold pins of the pommel were produced by rolling a piece of sheet metal into a conical tube, which was subsequently soldered to the pin head. Remains of a resinous material and fragments of gold foil are still visible on the tip of the pin. These come from the tenon on top of the hilt, which was covered with gold foil and can be seen through the rock-crystal pommel.

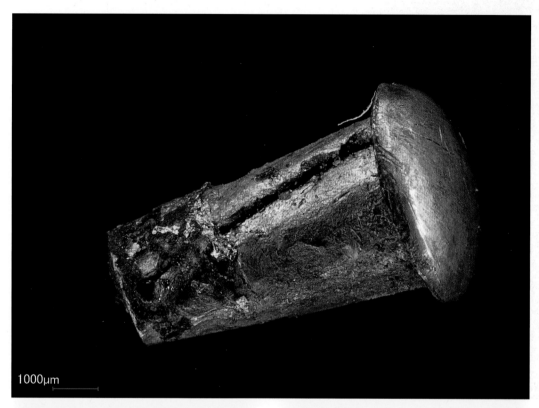

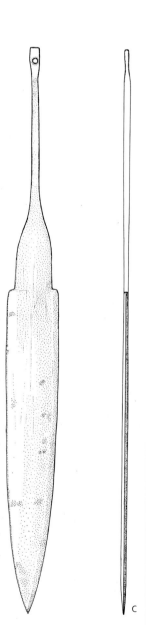

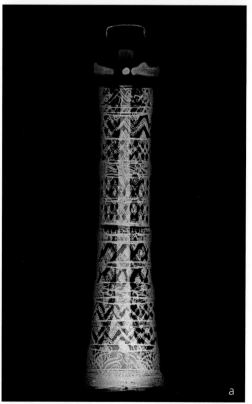

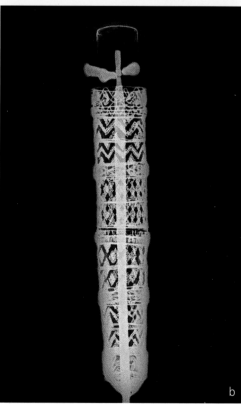

**Fig. 19** (a) A small metal dowel connects the tang to the hilt. It is impossible to make any further statement regarding its material based on the X-ray picture alone. Slightly conical pins (with heads) made of gold foil keep the rock-crystal pommel in place. (b) An X-ray image showing the side of the handle. (c) Drawings of the meteoritic iron blade (front and side view). Scale 1:2

16   Simply the best—the dagger with the iron blade and gold sheath

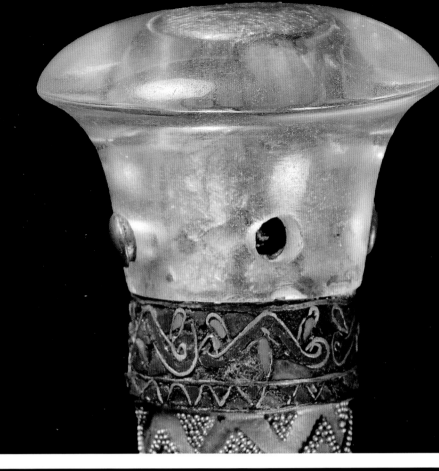

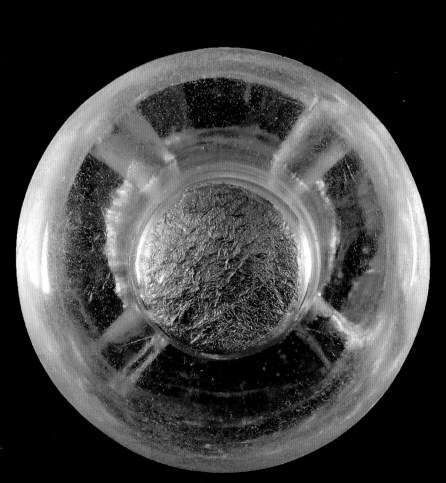

Fig. 20 The almost perfectly symmetrical pommel made of rock crystal (a). The top view of the pommel (b) shows the drill holes through which it was attached to the dagger by means of small gold pins. These holes are slightly conical, and do not show any noticeable offset.

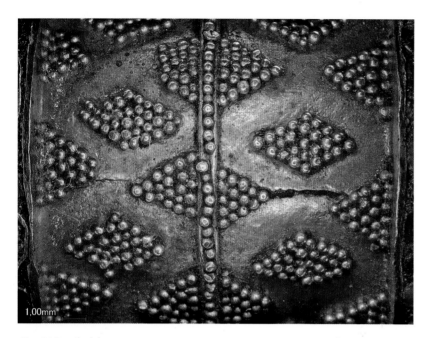

**Fig. 21** Detail of the soldered joint on the cylindrically bent sheet metal. It is possible that the cylinder thus formed was simply slid over the hilt.

The hilt is completely covered with gold sheet[33] that is worked—more or less—into a cylindrical shape, widening from a round cross-section at the pommel to an elliptical one toward the blade. As a result, the width of the handle increases when viewed from the top (Fig. 21). The part closest to the blade is lenticular and has been further compressed.

The handle of the dagger is divided into nine decorative zones, which alternate horizontally between bands decorated with colorful stone and glass inlays, and sections that are adorned with gold filigree[34] and gold granulation (Fig. 22a and b),[35] save for one area that is decorated with a combination of compartmental inlay[36] and wire-work techniques (Zone 9, see box). Some of the granules on this handle are now lost, which hints either at wear through usage or an unstable solder joint.

**Zone 1** (from the top) lies just below the pommel. It consists of a frieze with very broad and simple pendent lily-palmettes with drop-like elements. They are decorated with opaque red and turquoise glass (or feldspar) inlays on a lapis lazuli background. The frieze concludes with a zigzag pattern running below, showing alternating inlays of red glass (top triangles) and lapis lazuli (bottom triangles).

Like the other decorative gold bands, **Zone 2** is decorated with gold granules. The line of granulation in the center that divides the zone is placed on top of a double round wire, which thus forms a groove to receive the granules. Each of the halves thus created is adorned with (from top to bottom) a row of downward-pointing granulated triangles, a double zigzag line, and a row of upward-pointing granulated triangles. The triangles comprise in each case about fifteen to nineteen granules.

**Zone 3** consists of a frieze of lotus buds placed on their sides (see also Fig. 23). The background is lapis lazuli; the buds have red glass inlays. On one side of the handle, the small round blossoms that flank the buds alternate between red and yellow inlays, while on the other they switch between red and turquoise glass (or feldspar) inlays.

**Zone 4** is similar in design to the decorative layout of Zone 2, with the zigzag band replaced by diamonds.

**Zone 5** is unique—that is, it does not reoccur in an identical or even similar way in the further course of the decoration. It is a frieze with two rows of a scale or feather *(rishi)* pattern, in which yellow and red glass inlays alternate. The background between these motifs is inlaid with lapis lazuli.

**Zone 6** corresponds to Zone 4.

**Zone 7** corresponds to Zone 3 with the exception of the "blossoms" which are here inlaid with yellow, turquoise, and red glass in an irregular order.

**Zone 8** corresponds to Zone 2. Here, the triangles comprise about twenty-one granules each. On one side, nearly all the granules of the dividing line are lost (see also Figs. 21; 45b). It remains unclear whether this loss was caused by poor manufacturing quality or actual use of the dagger.

The motif in **Zone 9** resembles that of Zone 1. However, the palmette (or volute-like plant) is broader, more elaborate, and has a second layer of leaves. It is oriented toward the pommel and has red, yellow, and turquoise glass inlays. For the background, lapis lazuli was used. There is no zigzag frieze here. The filigree gold band, which was soldered onto the lower edge of the frieze, distinguishes this zone as well: respectively two so-called cord wires, each consisting of two round wires that were plied together—that is, twisted together (not torsion-bent), one in an S-twist, the other in a Z-twist—form the upper and lower edge of the gold band. In this way, they create a herringbone pattern with acute angles. These bands are also known as false plaid and represent the oldest form of the two-wire decoration. In Mesopotamia, they are attested since the third millennium BC; in Egypt since the second (Wolters 2014).

The plaited band in the center of this frieze was made from three strands, each consisting of two—this time, parallel—wires.[37] The distortion of the small filigree band (see also Fig. 25) was probably caused by the excessive compression of the lower edge of the gold sheet (covering the hilt) against the blade.

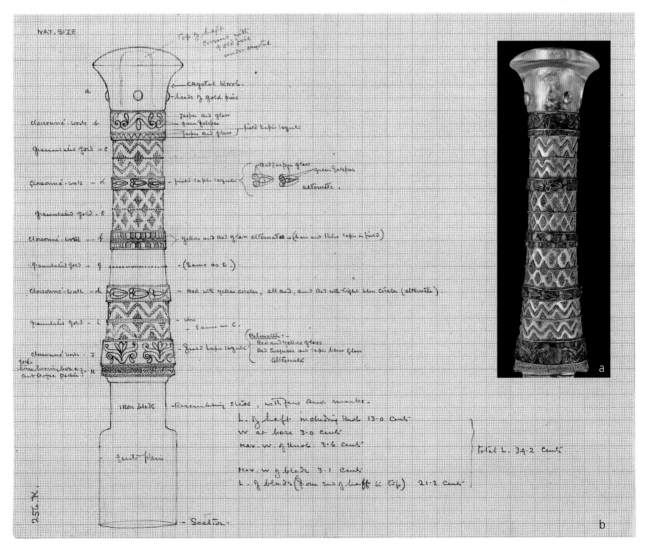

**Fig. 22** (a) The dagger handle in detail. (b) A 1:1 scale drawing of this handle made by Carter as part of the documentation; this was a common practice for Carter.

The dagger 19

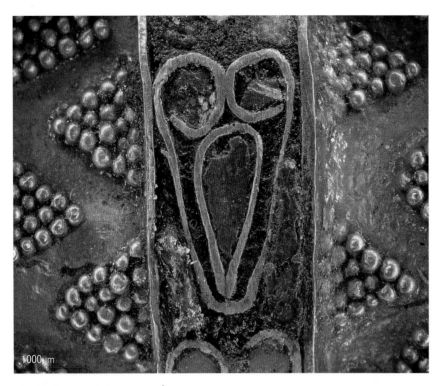

**Fig. 23** Close-up of the material used to fix the red inlays in decorative Zone 3. It was probably pigmented with yellow-gold orpiment, which might originally have had a more reddish hue. The glossy transparent material on the surface is probably microcrystalline wax that was applied relatively recently.

Little strips of gold sheet were soldered onto the gold cover of the hilt, acting both as a framework for the design of the colorful decoration and creating the compartments for the inlays. These inlays consist of thin stone or glass slices that are (roughly) chipped into shape and set into the cells with a mineral-based fixative, colored to blend in with the inlay (Fig. 23).[38] Inlays of dark blue lapis lazuli, green feldspar (?), and red, blue, turquoise, and yellow glass were used in the decoration of the handle.

It is well known that the Egyptians attributed values and meanings to stones and other materials. But as is often the case when examining Tutankhamun's burial goods, it must be stated that a special significance was attributed to the artificial color equivalents made of glass in almost the same way as to their archetypes made of gemstones, that is, the specific coloring was attributed an (almost) equal role, as was the individual significance and characteristic efficacy of the materials themselves.[39]

The undecorated iron blade is symmetrical, slightly convex, and pointed. It has a flat lenticular cross section. The edges have been ground and are still sharp (Fig. 24). It is striking that the blade does not fit perfectly into the handle: about two centimeters of the extended tang (or *ricasso*?) protrude from the bottom of the handle. The fact that the dagger does not have the expected clamp between the handle and the blade cannot be explained from the viewpoint of weapon technology or aesthetics. In order to cover such a large area as between the shoulder of the iron blade and the handle, any clamp would have to be a very unusual form. This, in addition to the noticeably compressed lower edge of the handle and the distortion of the gold filigree band, supports the hypothesis that the blade and the handle were not originally made for one another and were joined only at a later stage (Fig. 25).

## The sheath

The sheath, which is decorated on both sides, consists of two gold sheets that are crimped together. The side that was found facing up in situ (thus, the front—see Fig. 15) is decorated with a framed motif consisting of vertically aligned volute plants that was chased[40] into the gold. From the outside moving toward the center, the frame comprises a ribbed band, a two-ply twisted (Z-twist) rope, and a plain band that directly encloses the motif (Fig. 26a and b).

The back is decorated with a framed feather pattern, which Egyptologists refer to by the Arabic word *rishi*. The feathers are oriented toward the tip of the sheath, where the motif ends with the chased representation of a canine head. The frame consists of two ribbed bands, although only the inner one is visible along the upper edge of the sheath, as the outer one has been folded inward.

A small loop of gold wire is soldered on each side of the sheath's opening to facilitate its attachment or suspension. The sheath is minimally wider than the iron blade, and thus seems to have been tailored to fit it perfectly, even covering the part of the tang (*ricasso*?) that protrudes from the handle. From this, we can assume that the sheath was custom-made for this particular combination of handle and blade, even if we can also conclude that the blade and the handle were not made for one another.

**Fig. 24** The surface of the iron blade is finely executed and polished. Only a few marks from the polishing process are discernable along the blade.

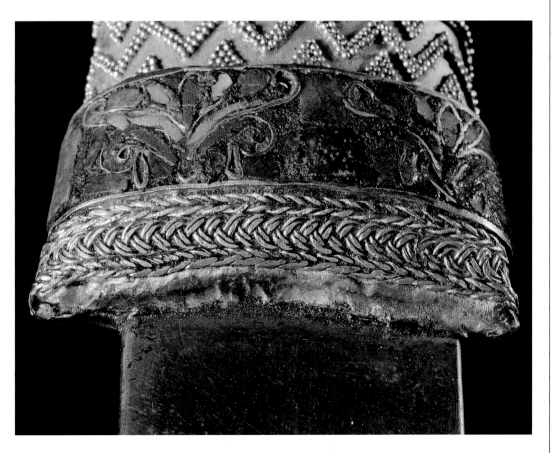

**Fig. 25** At its lower end—that is, toward the blade—the hilt cover was compressed so that its outer edge was basically squeezed against the blade. The compression also caused the strong distortion of the filigree plaited band, and could indicate that the blade was not originally meant for this dagger.

The sheath 21

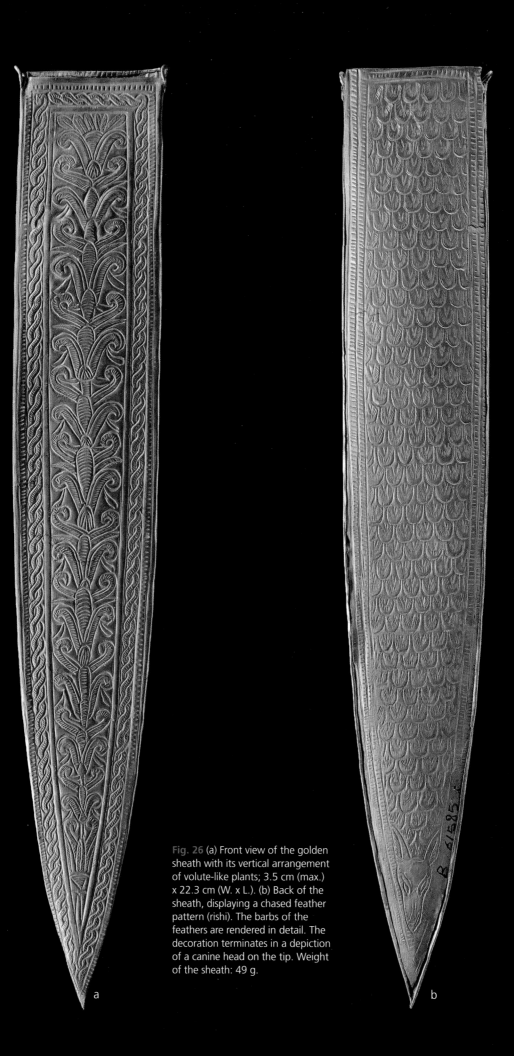

Fig. 26 (a) Front view of the golden sheath with its vertical arrangement of volute-like plants; 3.5 cm (max.) x 22.3 cm (W. x L.). (b) Back of the sheath, displaying a chased feather pattern (rishi). The barbs of the feathers are rendered in detail. The decoration terminates in a depiction of a canine head on the tip. Weight of the sheath: 49 g.

# 6 Iron in pharaonic times

. . . a warning at least is necessary, lest we rush into absurd revelations with regard to that metal [iron] and its use by the ancient Egyptians. (Carter 1927, 90–91)

Every new analysis of iron finds from prior to the Iron Age causes a worldwide sensation and enthusiasm, provided that the results show that these objects were made of meteoritic iron and are thus of "extraterrestrial origin."[41] However, from an archaeological and technological point of view, the real sensation would be to discover smelted iron of such an early date, as there is so far no archaeological evidence for iron extraction from ore in Egypt at that time.

The knowledge of iron ore extraction and smelting spread in different regions of the world at different times. However, meteoritic iron[42] was already in use before the beginning of these individual, local Iron Ages, at a time when iron was considered to be particularly valuable due to its rare occurrence. It was thus used predominantly for the production of cult objects and jewelry. This extraordinary appreciation is probably related to the "desire for new materials to serve as aesthetic visual displays of identity."[43] In general, the development of iron from a "luxury good to a regularly used metal" is only observable at a much later stage (Yalçin 2005, 498). The oldest known finds of meteoritic iron come from Central Anatolia and Egypt. For example, a dagger with an iron blade was discovered in Alaca Höyük (Çorum İli in modern Turkey),[44] in a context dated to about 2400–2300 BC.

In Egypt, the earliest known evidence for the processing of meteoritic iron comes from decorative beads that were found in two tombs from the predynastic Naqada culture (about 3500 BC) in al-Gerzeh (Johnson et al. 2013; Rehren at al. 2013, with further literature). A small amulet in the shape of a fishtail knife, (pesesh kef), which the Egyptians used in the Opening of the Mouth ceremony, was found in the tomb of Queen Ashait, a secondary wife of Mentuhotep II of the Eleventh Dynasty (about 2000 BC), at Deir al-Bahari (Brunton 1935).

A discovery[45] made by Christiane Desroches-Noblecourt in the Valley of the Queens—or, rather, in the adjacent area—has, so far, not been considered in the discussion, even though it confirms the use of probably unprocessed meteoritic iron. At the end of the relevant wadi, there lies a sacred grotto that was used during the Eighteenth Dynasty in particular. It is interesting in this context that the inscription "water of the sky" (mw en pet) was carved several times into its walls. This water was apparently responsible for the formation of this place, and thus accounts for its sacral meaning. Not far from this grotto, a dam or water barrier (the author uses both terms) was built, containing a long row of meticulously positioned iron meteorites,[46] interpreted by Desroches-Noblecourt as a means of magical protection. In conclusion, the meteorites must have been placed intentionally into the dam in order to safeguard the valley against heavy floods (Desroches-Noblecourt 2003, 100–101 pl. XXV, 175).

Iron production is documented as early as the sixteenth century BC in the Hittite Empire and it enjoyed a virtual monopoly status until the twelfth century BC. Iron could not yet compete in use with already known materials like copper alloys (Yalçin 2005, 500), and the Hittites originally used it solely as a decorative metal, valuing it at over eight times its weight in gold.[47]

From the twelfth century BC onward, it was possible to harden iron by carburizing, and it was exclusively this tempering that made iron suitable and valuable for the production of weapons and utility tools.[48] Ancient texts refer to different qualities of iron, which might imply an earlier knowledge of carburizing than revealed archaeologically. A thirteenth-century BC Hittite king wrote, probably to an Assyrian king: "Regarding the good iron, about

which you wrote to me—good iron in Kizzuwatna in my seal-house, it does not exist. As I have already told you, the time for producing iron is bad. They will produce iron, but they will not have finished yet. As soon as they have finished, I will bring it to you. For now, I am sending you an iron (sword/dagger)" (Siegelova 1984, 156). This text clearly shows that people were already aware of differences in the quality of the material and it is assumed that the expression "good iron" actually refers to steel (Yalçin 2005, 499). There may be a further reference to steel in the Amarna Letters, the diplomatic correspondence from Akhenaten's capital city. An oft-quoted letter from the Mitanni ruler Tushratta to Pharaoh Amenhotep III lists daggers with iron blades, a gilded iron bracelet, and an iron mace-head among Tushratta's wedding gifts to the pharaoh.[49] According to Wilsdorf, the letter writer clearly distinguishes between a "steel dagger" and an "iron dagger." However, the text itself only seems to refer to the classification of the objects into different quality types (Wilsdorf 1954, 79–80).

Although iron ore is plentiful in many parts of Egypt (Lucas and Harris 1962: 235–36), the smelting of iron is only documented from the sixth century BC onward (Ogden 2000, 159–68). The use of telluric iron—iron that naturally occurs in a metallic form—is always mentioned as a theoretical possibility for ancient iron working (Photos 1989, 404–405; Yalçin 2005, 495). According to the present state of knowledge, however, only a few places worldwide provide this material in a usable quality and quantity, and none is attested near Egypt.[50]

When it comes to the different terms used to designate iron in Mesopotamia and Egypt, the interpretation of the ancient written sources is rather confusing for the layman. Moreover, a discourse is still simmering over whether Hittite and Egyptian terms refer to a specific type of metal—in this case, copper or iron—or whether they perhaps denote the mere "brightness of the sky."[51] These expressions might also simply reflect their understanding of the divine manifesting in the form of iron.[52] In comparison with this ongoing discussion, researchers generally agree that the Egyptian phrase *bia en pet*—which can be read as the "iron of the sky"[53]—refers from the New Kingdom onward to meteoritic iron, and eventually to smelted iron, too (Bjorkman 1973, 114).

## Meteoritic iron . . .

Meteorites are generally divided into classes of stony, stony iron, and iron meteorites. Within these categories, iron meteorites represent the rarest type. Only about 4.5 percent of all meteorites recovered are iron meteorites; in most cases, these originate from the fragmented metal core of melted asteroids. The content of metal in iron meteorites amounts to over 90 wt% (percentage by weight), with the remaining percentage containing inclusions of troilite, an iron sulfide mineral; of schreibersite, an iron nickel phosphide; of graphite; and of various silicates. In general, iron meteorites vary substantially in their chemical composition, with their nickel content[54] up to 25 wt%, the cobalt content up to 0.4 wt%, the phosphorus content up to 0.1 wt%, and the germanium up to 0.4 wt%. They are divided into fourteen chemical groups.[55] The main criteria for this classification are based on the contents of the chemical elements nickel, gallium, germanium, and iridium. However, over 10 percent of all iron meteorites are considered "ungrouped," and thus do not belong to any of the defined groups (Buchwald 1975, 60). The minerals within iron meteorites are grain-sized and their actual dimensions range between the submillimeter and the decimeter range.

The traditional categorization of iron meteorites into their structural classes of hexahedrite, octahedrite, and ataxite, rests on their macroscopic structure. The latter depends on the overall nickel content and manifests itself in most iron meteorites, after an etching, in the form of characteristic lamellae. This so-called Widmanstätten pattern is an oriented intergrowth of the minerals kamacite and taenite. However, this lamellar pattern is not discernable in iron meteorites once their nickel content exceeds 20 wt%; they are thus referred to as ataxites (Greek, meaning "without structure").

Under certain circumstances, this structural division can also be dependent on chemical composition. Thus, hexahedrites have, for instance, a comparatively low nickel content and exhibit Neumann lines, which should not be confused with the Widmanstätten pattern (Neumann 1848, 45–56). Octahedrites come next in line, with a medium-to-high nickel content: thus, they also reveal the characteristic Widmanstätten pattern. On the basis of the conformation of this structure,

this meteorite type is further divided into five subgroups ranging from the coarsest to the finest octahedrites, and with a constantly rising nickel content. Another group, the so-called plessites, should be considered an intermediate group between octahedrites and ataxites (Brandstätter, Ferrière, and Köberl 2012, 145–47, 161).

## ... and its processing

The processing of meteoritic iron for the production of artifacts is a topic that is continuously discussed in the archaeological literature. Because of the scarcity of the available information, the main problem is the mostly speculative nature of this discourse, which is predominantly based on assumptions rather than data.

In most cases, the relevant objects are unique and not mass-produced, so are also of paramount importance for archaeology: invasive or destructive analysis is accordingly forbidden by their custodians. Only some older publications (Buchwald 1992, 142–43; Lorenzen 1882 cited in Buchwald 1992, 145), which reveal a rather hands-on approach toward the original objects, provide us with reliable information on the prehistoric up to the historic methods for processing meteoritic iron. These authors assume that the material was cold worked and maybe polished afterward. They excluded the process of forging and understood the existing evidence for heat exposure as unintentional and unrelated to the production method (Buchwald 1992, 171–72). Furthermore, recent archaeological experiments have shed new light on the topic (Buchwald 2005, 25ff.). In 2016, Johnson comprehensively presented her experimental work on the reproduction of a bead from al-Gerzeh that she had previously analyzed (Johnson and Tyldesley, 2016).

In general, meteoritic iron can be worked in a "warm" manner through reshaping it,[56] or in a "cold" way by either reshaping it or using techniques like grinding, chiseling/filing, and polishing that remove the metal. As with the processing of smelted iron, there will also be scale and melt loss during the forging of meteoritic iron, which might even affect the surface composition of the object to a minor degree. However, it is questionable whether these changes would remain traceable because scale layers are usually removed after the process, exposing the underlying bare metal surface. Moreover, possible carburization of the material in the forge cannot be categorically excluded, although the non-invasive analytic techniques used could not answer this question.

In addition, it became clear that the Widmanstätten pattern of meteoritic iron remains discernable on worked objects,[57] even if they had undergone a high level of reshaping and repeated heating. In the context of cold-worked meteoritic iron, it can be assumed that the overall composition remains unchanged as well.

However, the extent to which the material can be bent depends not only on its composition but also on the phase content and the structure. Even small amounts of non-metallic inclusions like troilite, schreibersite, or chromite severely reduce the fracture toughness of the material, and can lead to brittleness during the reworking process. This is due to the fact that dislocations in the crystal lattice accumulate in areas of inclusions and, hence, provide the ideal starting point for crack formation. In principle, though, it is still possible to cold work meteoritic iron.[58]

However, meteoritic iron can also be shaped by simply grinding and polishing it, a labor-intensive process during which a large amount of the material is wasted.[59] Nonetheless, it is noteworthy that ancient Egyptian craftsmen excelled above all in this particular technique, as the many surviving ground and polished stone, obsidian, and rock-crystal artifacts from Egypt demonstrate.

|  | Cr | | Fe | | Co | | Ni | | Reference |
|---|---|---|---|---|---|---|---|---|---|
|  | lit. | meas. | lit. (bal.) | meas. | lit. | meas. | lit. | meas. | |
| Boguslavka | 0.0070 | 0.01 | 93.74 | 94.1 | 0.448 | 0.42 | 5.46 | 5.2 | Wasson, Huber, Malvin 2007 |
| Braunau | N/A | 0.01 | 93.8 | 93.9 | 0.42 | 0.49 | 5.4 | 5.3 | Jochum, Seuffert, Begemann 1980 |
| Calico Rock | 0.0077 | 0.01 | 93.94 | 93.8 | 0.451 | 0.45 | 5.56 | 5.6 | Wasson, Huber, Malvin 2007 |
| Chinga | 0.089 | 0.09 | 82.83 | 83.3 | 0.577 | 0.58 | 16.5 | 16.4 | Rasmussen et al. 1984 |
| Hoba | 0.018 | 0.01 | 82.78 | 82.8 | 0.781 | 0.75 | 16.3 | 16.2 | Campbell and Humayun 2005 |
| Lombard | 0.0046 | 0.01 | 93.71 | 93.5 | 0.458 | 0.44 | 5.5 | 6.0 | Wasson, Huber, Malvin 2007 |
| Prambanan | 0.005 | N/A | 89.13 | 89.0 | 0.70 | 0.66 | 10.1 | 10.1 | Kracher, Willis, Wasson 1980 |
| Tlacotepec | 0.016 | 0.02 | 83.55 | 83.0 | 0.77 | 0.78 | 15.6 | 16.0 | Campbell and Humayun 2005 |
| Santa Clara | 0.008 | 0.01 | 81.88 | 81.6 | 0.78 | 0.79 | 17.2 | 17.4 | Campbell and Humayun 2005 |
| Skookum | 0.004 | 0.00 | 81.56 | 82.0 | 0.79 | 0.81 | 17.4 | 17.0 | Campbell and Humayun 2005 |
| Tlacotepec | 0.016 | 0.02 | 83.55 | 83.0 | 0.77 | 0.78 | 15.6 | 16.0 | Campbell and Humayun 2005 |

**Table 1** Known (lit.) and measured composition of meteorites that were used in the calculation of the calibration curve. The values indicated in the bibliographical references were rounded; this rounding considers the measurement errors found in the literature. The iron values of the literature data were calculated as difference (bal.). All the values are in wt%. N/A: not analyzed.

| JE # | Cr | Fe | Co | Ni | Cu | Ge traces | Total | Coverage of the detector area |
|---|---|---|---|---|---|---|---|---|
| 61295 | N/A | 86 | 0.7 | 10 | 0.4 | - | 96.4 | good |
| 61296 | N/A | 85 | 0.8 | 11 | 0.1 | - | 97.4 | good |
| 61297 | N/A | 87 | 0.8 | 10 | 0.1 | - | 97.2 | good |
| 61298 | N/A | 91 | 0.5 | 8 | 0.0 | + | 99.3 | good |
| 61299 | N/A | 86 | 0.7 | 10 | 0.1 | ? | 97.7 | incomplete |
| 61300 | N/A | 85 | 0.8 | 11 | 0.2 | - | 97.0 | moderate |
| 61301 | N/A | 89 | 0.7 | 7 | 0.1 | + | 96.5 | moderate |
| 61302 | N/A | 85 | 0.8 | 13 | 0.2 | + | 98.0 | incomplete |
| 61303 | N/A | 85 | 0.8 | 10 | 0.5 | - | 96.6 | moderate |
| 61304 | N/A | 87 | 0.7 | 8 | 0.1 | - | 95.9 | incomplete |
| 61305 | N/A | 86 | 0.7 | 10 | 0.3 | + | 97.0 | incomplete |
| 61306 | N/A | 84 | 0.7 | 10 | 0.2 | - | 95.3 | incomplete |
| 61307 | N/A | 88 | 0.7 | 8 | 0.2 | + | 97.0 | moderate |
| 61308 | N/A | 85 | 0.8 | 11 | 0.1 | - | 97.0 | moderate |
| 61309 | N/A | 89 | 0.6 | 6 | 0.1 | - | 96.5 | incomplete |
| 61310 | N/A | 86 | 0.7 | 11 | 0.1 | - | 97.8 | moderate |

**Table 2** Outcome of the qualitative analysis of the chisels. The low totals result from the fact that the measurements' window was not always covered in its entirety (because of the very small cross section of the tips) and from the corrosion on the surface of the chisels. All the values are in wt%. JE: *Journal d'Entrée* of the Egyptian Museum Cairo. N/A: not analyzed.

# 7 "Iron from the sky" in the tomb of Tutankhamun

When Howard Carter first saw Tutankhamun's iron dagger, he became so excited that he almost believed that the iron blade might be made of steel.[60] However, the assumption that it is actually meteoritic iron arose relatively early as well (Wainwright 1932, 7, 14; Lucas and Harris 1962, 239). In the majority of cases, only the dagger (the best-known iron object from the tomb) is considered, while the other pieces made of iron are not dealt with—or only partially at best. Leslie Aitchison vehemently disagreed with the possible meteoritic origin of the dagger—again, the other objects were not even mentioned in this instance—and postulated that it was made from smelted iron, without offering any proof (Aitchison 1960, 94–95).

Even though it was suspected more than once that all the iron artifacts might be meteoritic in origin, for a long time there was no evidence based on chemical analyses. Shortly thereafter, Bjorkman mentioned a first analysis in favor of a meteoritic origin, but did not provide any data (Bjorkman 1973, 124–25). The first published compositional analysis of the dagger revealed an iron content of 93.3 wt% and a nickel content of 2.8 wt%, as well as 0.09 wt% cobalt and 0.08 wt% aluminum. Based on these test results, it was determined that the iron blade did not consist of meteoritic iron (Helmi and Barakat 1995, 288).[61] The only analysis that is congruent with our study was published in 2016 (Comelli et al. 2016)[62]—but even this

> The portable XRF (X-ray fluorescence) method can be used to analyze the chemical composition of most solid materials. Due to the physical background of the method, no elements lighter than sodium can be detected. Quantification of elements lighter than aluminum is possible, but usually connected with large uncertainties. The measurements were carried out with a portable XRF device (Tracer IV-SD, Bruker AXS). The device uses a Rh-tube that was operated with an acceleration voltage of 40 kV and an anode current of 10 µA. A 25 µm Ti + 300 µm Al primary filter was employed. Moreover, a 10 mm² SDD was used with a resolution of 145 eV at a count rate of 100,000 cps at 5.9 keV (Mn Kα). In its focus, the tube has an oval focal spot size of 4 mm x 3 mm (established by means of illuminating and evaluating a standard X-ray film). The quantification was performed with the help of the CFZ-method. The determining principle was a calibration curve that is based on the polished and otherwise quantified samples of the meteorites Boguslavka, Braunau, Calico Rock, Chinga, Hoba, Lombard, Prambanan, Santa Clara, Skookum, and Tlacotepec (Campbell and Humayun 2005, 4736; Jochum, Seuffert, and Begemann 1980, 60; Kracher, Willis, and Wasson 1980, 774; Rasmussen et al. 1984, 806; Wasson, Huber, and Malvin 2007, 763).[63] The meteorites were requantified using this calibration curve in order to guarantee its reliability (see Table 1). The results from the analyses of the iron objects rest upon a varying number of measurements, all compiled in Tables 2–3. As it was impossible to modify these objects in any way, the measurements of the chisel tips (1 point analyzed per chisel), the bracelet (7 points analyzed), the headrest (7 points analyzed), and the dagger (10 points analyzed) took place on unprepared surfaces.
>
> Due to their small size, the analyses of the iron tips are based on individual measurements and can only be considered as semi-quantitative, as the measurements were carried out on their corroded surfaces.

investigation excludes, once again, Tutankhamun's other iron objects.

The results of our investigations show that all the iron objects from the tomb of Tutankhamun genuinely consist of meteoritic iron—as was, in fact, to be expected. This can be deduced from the nickel content, which lies without exception above the limit of 4 wt% (Buchwald 1992, 155; 2005, 23); therefore, a telluric origin for Tutankhamun's iron can safely be discounted.

## The chisel tips

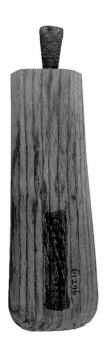

The condition of the chisel tips poses an analytical problem that should not be underestimated, because they are heavily corroded compared with the other iron objects in the burial equipment. This corrosion, as well as the fact that some of the tips are too small to cover the measurement window of the portable X-ray fluorescence spectrometer, adds to the low totals, amounting to only 95.3 wt% in some cases. While the analyses should thus be regarded as only semi-quantitative, the results—even though they are heterogeneous—are still listed in Table 2 in order to allow at least a rough classification.

The iron content of the different tips fluctuates between 84 and 91 wt%, and the nickel content ranges from 6 to 13 wt%. The cobalt content, with values between 0.5 and 0.8 wt%, is significantly higher than those of the other objects. Traces of germanium could be found on five of the sixteen artifacts. Besides the obvious variation in the results, the copper level of up to 0.5 wt%, encountered in some of the chisel tips, should likewise be highlighted, as it is clearly elevated—at least, in comparison with that of the other objects (Table 3).

Of course, these readings do not correspond to the original and unmodified composition of the iron meteorite used. It is unclear whether the iron tips are corroded completely or only superficially. Such comparatively heavy corrosion of meteoritic iron seems rather unlikely when one considers the storage conditions in Tutankhamun's tomb. The question remains: what could have caused this corrosion? Did other substances (of whatever nature) influence certain element contents, or is the original composition still extant (albeit in a completely corroded form) without added or removed elements? As the original function and use of the tools remains unknown, we do not know whether the iron parts came into contact with corrosive substances, or what they were.[64]

## The *wedjat* amulet

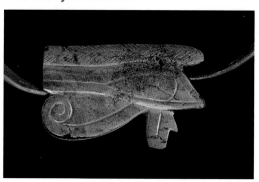

A clear fluctuation is also noticeable in the measurement results of the *wedjat* amulet. The average iron content is 90.0 wt%. In comparison with the results gained from the headrest and the dagger, the average nickel content of only 8.0 wt% represents the lowest measured value. The cobalt content amounts to 0.49 wt%, whereas chromium was only accounted for in a single test point (see Table 3). The low totals of the analyses are caused by the presence of zinc, which was not taken into account in the calibration curve.

As zinc was not calibrated for the analysis of the meteorites, control measurements were carried out with the factory calibration "standard alloys." The peak in the XRF-spectra suggests a zinc content of over 0.3 wt%, a value that is unusually high for meteorites (Buchwald 1975, 83; Bridgestock et al. 2014, 157). We therefore assume that this is due to contamination. Lucas remarked that the *wedjat* was "Cleaned with fine dust + caustic soda."[65] "Fine dust" might refer to ZnO (zinc oxide), which is mainly used as a pigment but is also employed as a mild polishing agent for metals (Brepohl 2008, 377). Thus, it is possible that some residue of this material settled in the pores of the amulet's surface.[66]

The bracelet itself consists of a peculiar reddish colored gold alloy, which appears to be the result of corrosion.

## The miniature headrest

The measurement results for the headrest are likewise not homogeneous. Analysis gives its iron

content as 90.5 wt%, the nickel content 8.8 wt%, cobalt content 0.47 wt%, and the chromium content amounts to 0.06 wt%[67] (see Table 3). The headrest consists of two separate parts, which do not differ significantly from each other in their chemical composition, and it can thus be assumed that they were made from the same meteoritic iron ingot.

For the very small soldered joint, only a mixed analysis of the iron, the solder, and the whitish filling could be made.[68] Besides iron, nickel, and cobalt—in other words, elements that are typically found in meteoritic iron—traces of aluminum, silicon, phosphorus, sulfur, calcium, copper, arsenic, and zinc were also detected. When disregarding the elements associated with meteoritic iron, copper and zinc can be attributed to the solder, and aluminum, silicon, phosphorus, sulfur, and calcium to the fill mass. The arsenic noted in the spectrum might indicate a contamination of the filling, although the exact classification is impossible. The elements detected and the appearance of the fill mass allow it to be interpreted as a plaster or carbonate-based mass that was mixed with a white siliceous compound, possibly fine-ground rock particles.

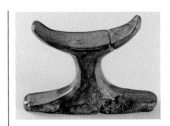

|  | Cr | Fe | Co | Ni | Ge | Total |
|---|---|---|---|---|---|---|
| Dagger blade | | | | | | |
| | 0.03 | 86.8 | 0.58 | 12.8 | N/A | 100.2 |
| | 0.03 | 86.7 | 0.59 | 12.8 | N/A | 100.1 |
| | 0.04 | 86.4 | 0.60 | 12.9 | N/A | 100.0 |
| | 0.04 | 86.8 | 0.56 | 12.7 | N/A | 100.1 |
| | 0.04 | 86.8 | 0.58 | 12.8 | N/A | 100.2 |
| | 0.04 | 86.8 | 0.57 | 12.8 | N/A | 100.2 |
| | 0.03 | 86.7 | 0.60 | 13.0 | N/A | 100.3 |
| | 0.04 | 86.7 | 0.56 | 13.1 | N/A | 100.5 |
| | 0.03 | 86.6 | 0.57 | 13.1 | N/A | 100.2 |
| | 0.03 | 86.8 | 0.55 | 13.1 | N/A | 100.4 |
| Average | 0.04 | 86.7 | 0.58 | 12.8 | | |
| Headrest | | | | | | |
| | 0.03 | 89.6 | 0.48 | 9.6 | traces | 99.7 |
| | N/A | 90.8 | 0.45 | 9.0 | traces | 100.2 |
| | 0.08 | 90.6 | 0.47 | 8.0 | traces | 99.2 |
| | N/A | 90.9 | 0.45 | 8.4 | traces | 99.8 |
| | 0.09 | 90.9 | 0.51 | 8.0 | traces | 99.6 |
| | N/A | 90.9 | 0.48 | 8.8 | traces | 100.2 |
| | 0.04 | 89.6 | 0.47 | 9.7 | traces | 99.8 |
| Average | 0.06 | 90.5 | 0.47 | 8.8 | | |
| Wedjat amulet | | | | | | |
| | N/A | 89.3 | 0.48 | 8.5 | traces | 98.3 |
| | N/A | 90.2 | 0.49 | 8.0 | traces | 98.6 |
| | N/A | 90.0 | 0.48 | 8.3 | traces | 98.8 |
| | N/A | 89.4 | 0.48 | 8.4 | traces | 98.2 |
| | N/A | 90.3 | 0.52 | 7.7 | traces | 98.5 |
| | N/A | 91.1 | 0.49 | 8.0 | traces | 99.5 |
| | 0.02 | 90.0 | 0.50 | 7.4 | traces | 98.0 |
| Average | 0.02 | 90.0 | 0.49 | 8.0 | | |
| 2σ error | +/- 0.01 | +/- 0.15 | -/+ 0.02 | +/-0.1 | | |

**Table 3** Results of the analyses of the dagger blade, the headrest, and the *wedjat* amulet. The low totals stemming from the analyses of the *wedjat* amulet are due to the morphology of its surface and the zinc contamination. All the values are in wt%. N/A: not analyzed.

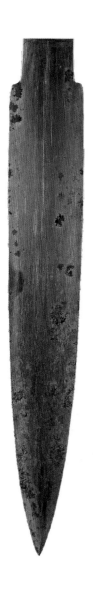

## The iron blade of the dagger

The dagger blade is characterized not only by the high quality of its craftsmanship but also by the particularly homogeneous chemical composition of its metal. The measurement results are more stable here, with the values for nickel only fluctuating between 12.7 and 13.1 wt%, and those for cobalt between 0.55 and 0.60 wt%. The blade has an average content of 86.7 wt% iron, 12.9 wt% nickel, 0.58 wt% cobalt, and 0.04 wt% chromium; germanium was not found above the detection limit (see Table 3).

The homogeneity of the material permits different interpretations. The raw material could already have been far more homogenous than that of the other objects to begin with. In this case, a fine or very fine octahedrite with a lamella width of 0.5 mm or under would be expected, which appears homogeneous in our analysis with a 4 mm x 3 mm focal point. It is also theoretically possible that the material was homogenized during the working process. However, such a technical step would have required a thorough understanding of ironsmithing, including the ability to forge-weld iron. Considering the current state of research—which provides no archaeological evidence for such high-temperature technology—it is far more likely that the blade was formed from a more homogeneous raw material.

The iron dagger is the only of Tutankhamun's iron objects for which there are comparative analyses. That undertaken by Daniela Comelli et al. in 2016 is the only one that can be used as a comparison. Portable X-ray fluorescence analysis determined a nickel content of 10.85 wt% and a cobalt content of 0.58 wt% (Comelli et al. 2016, 1304). The cobalt values agree closely with the measurements we obtained, but the nickel values show a significant deviation, possibly due to differences in the calibration.

In accordance with the evaluation of the present measurements listed in Table 1, we believe that the measurements published here are the most accurate so far and further improve the data pool of the already existing analyses. Additionally, the number of measurements taken per object allows the homogeneity of the material to be assessed.

---

During the analytical measurements of the blade, the gold composition of the bracelet and the dagger sheath was also analyzed in two spots with a Bruker Tracer IV-SD (for details on the hardware, see page 27). Contrary to the analytical approach chosen for the iron blade, the factory calibration "precious metals" was used for the analyses of the gold. The device was operated with an acceleration voltage of 40 kV, an anode current of 16.5 µA, and a 25 µm Ti + 300 µm Al + 150 µm Cu filter. The measuring time was 250 live seconds.

The bracelet does not consist of a highly cupriferous alloy, even though its intense reddish-gold tone would seem to suggest this. Its copper content fluctuates between 1.32 and 3.94 wt%, the gold content between 77.3 and 80 wt%, and the silver content between 17.3 and 18.6 wt%. Thus, the color effect is probably caused by a particular form of corrosion that is mainly known from the context of Egyptian gold. A tarnish layer comprising several gold, silver, and sulfur compounds might be responsible for this color (Frantz and Schorsch 1990, 142–48). However, these cannot be detected without performing a phase analysis—so this assumption must remain unverified here.

The results of the two measurements taken from the sheath show the following average values: 87.5 wt% gold; 10.2 wt% silver; and 2.15 wt% copper. The gold alloy of the iron dagger sheath thus nearly matches the composition of the gold dagger sheath (see page 45).

# 8 What do we know now, 3,300 years later?

Our investigation focused on the actual composition of the iron from Tutankhamun's burial equipment. We also sought to bring a technological and scientific point of view to consider the origin(s) of and modes of manufacturing these iron objects.

All Tutankhamun's iron has now been identified as meteoritic iron.[69] The germanium traces in the headrest, the *wedjat* amulet, and some of the iron tips speak definitively in favor of a meteoritic origin.[70] Germanium was not detected in the dagger blade; however, its nickel content of over 4 wt%—in this case an average of 12.8 wt%—could be interpreted as a clear indication of meteoritic provenance in this case too, because iron with such a high nickel content cannot normally have a terrestrial origin.

When considering the nickel and cobalt values of the analyzed objects,[71] they fall within the composition range of the iron meteorite groups IAB, IIICD, and IIF (see note 56). However, none of these groups has a chromium content high enough to relate to Tutankhamun's iron. In the case of the bracelet and the headrest, the results of the analyses are sufficiently similar to suggest they could both been made of material from the same meteorite. This hypothesis, however, can only be tested by means of a detailed trace-element analysis, which is not possible given the rarity and value of the objects. In comparison with the two other objects, the composition of the blade differs so much that there is no doubt that its material stems from another source.

Several factors complicate or hinder the task of searching for matching meteorites: New Kingdom Egypt was interconnected through extensive networks of trade relations and diplomatic contacts, so its area of influence spread far beyond its borders. Although contemporary texts list finished iron objects among diplomatic gifts (see page 24), there are no sources discussing the trade in iron as a raw material. Finally, the origin of a meteorite does not allow conclusions to be drawn regarding where objects were produced.

Only a handful of large iron meteorites are known from pharaonic times that could have provided the necessary raw material for the production of Tutankhamun's iron objects. One obvious source would be the so-called Kamil meteorite, which fell in the southwestern part of modern Egypt, probably between 2000 BC and AD 500 (Sighinolfi et al. 2015), leaving an impact crater of approximately 45 m in diameter. Over a thousand meteorite fragments—mostly within the gram range, but also up to a weight of 83 kg—were found recently (D'Orazio et al. 2011). However, the Kamil meteorite must be regarded as highly unlikely as a possible source for Tutankhamun's iron objects because it is an ataxite, with a nickel content of about 21 wt%, a cobalt content of 0.77 wt%, and a chromium content below the detection limit. It can be assumed that smaller finds—that is, parts of a meteorite that disintegrated while traversing the atmosphere—were completely processed in most cases, leaving no comparative material behind.

We think that any attempt to relate Tutankhamun's iron objects to a meteorite known to us nowadays will remain highly speculative. For such an attribution, a different analytical approach would have to be chosen, as the meteorite classification and identification used today is mainly based on the trace element pattern. Since this can only be identified by invasive analysis methods, it could not be determined for the iron blade (and the other artifacts) at present.

If we cannot locate the meteorites that provided the material for making the objects, can we locate the craftsmen? Were these iron objects manufactured by Near Eastern or Egyptian metalworkers? Another question is whether some pieces were made by craftsmen who were familiar with

handling this type of material, while other objects were produced by less-experienced workmen.

Carter suspected that the dagger might be of foreign origin: "Both daggers . . . are foreign in shape" (Carter 1927, 136). In her dissertation on daggers, Petschel concludes that Egyptian daggers generally do not exhibit any characteristically "Egyptian" technological or stylistic development, but that "stimuli were again and again adopted from the area extending between the Near East and the Mediterranean" (Petschel 2011, 284).

The quality of manufacture, its design and decorative techniques, comparative analyses of its stylistic classification, differing expertise in metal technology found throughout the Mediterranean, and even historical written sources have repeatedly supported the assumption that the dagger—and, in particular, its blade—might not have been produced in Egypt. How tempting it would be to believe that this is one of the iron daggers that King Tushratta intended to send to Amenhotep III (see page 24)! The hypothesis that the blade might have been introduced into the dagger handle only at a later stage—or, rather, replaced its original blade—certainly implies different places or times of production for the blade and handle, but it is still unclear what these could have been.

The compartmental inlay technique, as well as the granulation, are complex and specialized decorative procedures that were well-established in Egypt by the reign of Tutankhamun (see also notes 35, 36). Thus, they can be used as circumstantial evidence at best, but not as proof, that the objects were imported or produced by foreign craftsmen. While the rock-crystal pommel might be associated with Aegean material culture, its typically Egyptian shape suggests either manufacture in Egypt or foreign production for an Egyptian market. In any case, if it was imported, it could have been as an individual component. As a result, no clear overall picture on the origin of the dagger's handle and blade—possibly also of the sheath or certain semi-finished products—emerges from the perspectives of material science or production techniques or technology.

The evaluation of the other iron objects seems more obvious. Carter himself described them as of "rough workmanship" (see page 12), which leads to the assumption that they were made by a (possibly Egyptian?) craftsman with little experience in handling iron. Lucas saw what he considered the low quality of the headrest and chisel tips as an indication that they were produced in Egypt (Lucas and Harris 1962, 240).

From a technical point of view, the production of the chisel tips would not have presented a major challenge in terms of manufacture and thus offers no information about the region in which they might have been made. They are precisely shaped and set into handles of differing, presumably function-specific, forms. They compare in quality with other ancient Egyptian precision tools made of copper alloys.

The small *wedjat* amulet is an Egyptian motif, and there is nothing in its style to indicate that it was made by a foreign craftsman. Thin sheets of iron can be produced without complex smithing techniques, either by grinding the metal to shape or even by taking advantage of some meteorites' lamellar structure (caused by weathering) to remove individual thin layers of metal (Johnson and Tyldesley 2016, 414).[72] Its technical manufacture is impeccable; the decoration is finely ground and polished.

Two opposing conclusions can be drawn from study of the headrest amulet. One can argue that the craftsman was poorly skilled in ironworking, and so was unable to produce a high-quality, esthetically pleasing, and fully three-dimensional artifact from this rare material. Alternatively, considering the varying quality of the meteoritic iron available and the fact that the craftsman might have had a limited choice of this scarce material, one can say that the production of a three-dimensional object from such poor quality raw material should actually be considered a particular accomplishment.

Ultimately, all these artifacts could have been produced in Egypt or elsewhere.

This first thorough examination of the context of the finds, the technological investigation, and the scientific analysis of this object group has produced a series of new insights into the production technology of these items and improved our understanding of late Bronze Age metalwork in Egypt. This is particularly true for the method of construction of the dagger handle, but also for the material scientific classification of these iron artifacts. From

a scientific and technological point of view, it is currently impossible to arrive at a reliable conclusion as to the origin of Tutankhamun's iron objects or the craftsmen and materials involved.

Invasive analyses would provide further information on the origin and processing of meteoritic iron, but taking samples from these unique archaeological artifacts is out of the question. In addition, there have been only a few experimental studies on the preparation and treatment of meteoritic iron, which, so far, permit only partial conclusions to be drawn.

Research on ancient methods for processing meteoritic iron has not yet been concluded, and it would be advisable to await further archaeological discoveries and experiments in connection with early iron production techniques in Egypt and the Near East. The last word has not yet been written on Bronze Age iron technology, or Tutankhamun's iron!

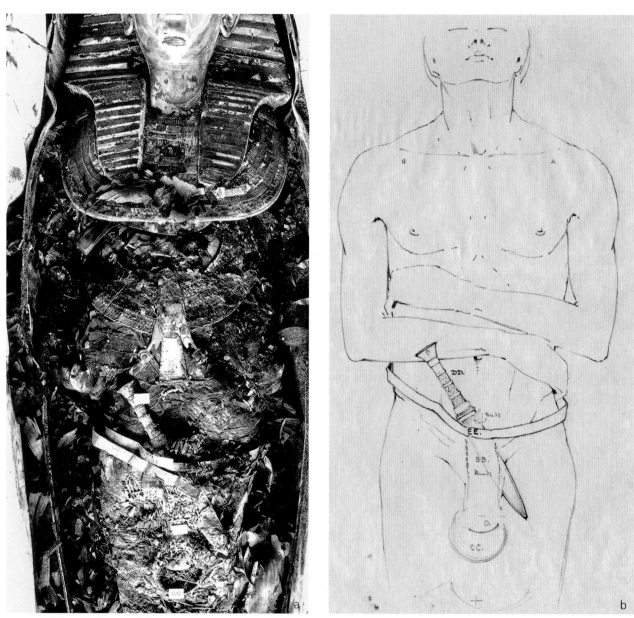

**Fig. 27** (a) The dagger with the gold blade and sheath in situ on top of the king's mummy. (b) Carter's drawing documenting the exact find position of the dagger and objects found nearby.

# Appendix: The golden dagger

## Simply the very best—the golden dagger and sheath

Tutankhamun's body was equipped with another, equally magnificent dagger, with a gold blade. Even though its examination cannot contribute anything to the focus of this study—namely, the iron objects from the tomb—we present our "autopsy" of the dagger with the gold blade. These insights are interesting, because the two daggers are stylistically related and are often dubbed "twins."

We studied the gold dagger alongside the iron dagger to explore whether the daggers might be similar, not only in style, but also in production technique, and to add to the ongoing discussion about their origins.

## The dagger

The dagger was found above the abdomen of the king. It was wrapped into a deeper layer of the mummy bandages than the iron dagger, but essentially mirrored its placement: the pommel lying to the right of his navel, the blade pointing to the center of the left thigh (Fig. 27a and b). It was secured by a thin sheet-gold belt (Carter no. 256ee) with a loop for the attachment of a royal bull's tail at the back,[73] essentially burying the king wearing two sets of regalia.

The handle of the dagger is lavishly decorated with gold granules as well as colorful stone and glass inlays; the blade is made of gold that has a slightly red hue (Fig. 28). Matching the handle, the pommel here has also been made of gold sheet, and decorated in the compartmental inlay technique. The lower, cylindrical end of the pommel is inserted into the hilt cover made of gold (Fig. 29a and b).

Two birds with outspread and downward-pointing wings decorate its front and back.[74] The colorless transparent glass inlays that make the bodies and heads of the birds are difficult to understand at first glance; their age hides an unexpected detail (Fig. 30a–c).

The somewhat oval top of the pommel is slightly convex and is decorated with an elaborate rosette consisting of papyrus and lily flowers in the guilloche style. In this case, the compartments were inlaid not only with stone and glass slices but also with thin glass rods.[75] It surrounds two cartouches containing the king's names in the center. The execution of these cartouches is rather crude: their outline is not clear, and the inscription manifests a lack of precision and possibly even traces of an earlier decoration (chasing).[76] The surface is coarsely filed and polished. The cartouches themselves are also arranged inharmoniously as they are not aligned along the central axis of the motif. However, the layout with alternating papyrus and lily flowers is exquisite (Fig. 31a–c).

A cylindrically bent gold sheet encompasses the hilt.[77] As in the case of the iron dagger, the handle form changes from a round cross section in the area of the pommel to an ellipse toward the blade. The surface ornamentation is divided into nine horizontal decorative zones, which, again, alternate between bands with colored stone or glass inlays and bands with gold filigree and granules (Fig. 32). Inlays of lapis lazuli and feldspar (probably also quartz or carnelian on a reddish background), as well as blue, red, yellow, and green glass were used for the decoration.

The clamp comprises two parts. The upper, bell-shaped, segment was slid onto the handle so that it partially overlaps the lower filigree band on the sides (see Figs. 28 and 32). In its color, the gold used here corresponds to the yellowish-gold of the handle. The lower segment might have been made in one piece with the dagger, or else separately produced and subsequently soldered onto the blade. Its color resembles the reddish-gold of the blade, which points to a higher copper content, and, thus, a harder alloy.

**Fig. 28** Full view of the dagger with the gold blade. In this case, the blade was decorated with a shallow central rib that is crowned by a volute plant; 31.9 cm (total L.), 11.8 cm (L. of handle), and 20 cm (L. of blade). Weight of the dagger: 289 g.

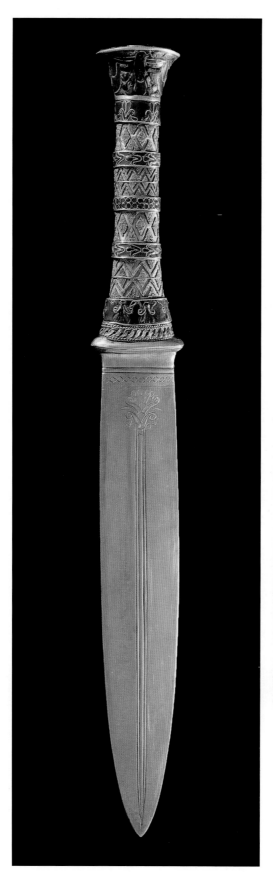

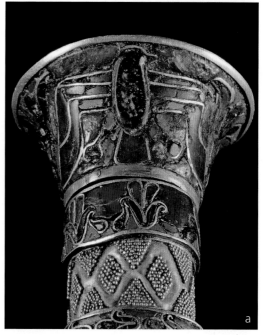

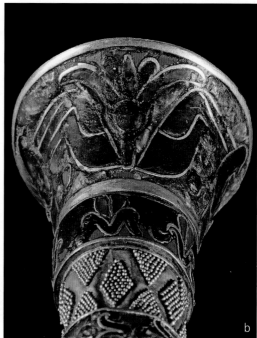

**Fig. 29** (a) The birds on the pommel are generally referred to as falcons, but the shape of their torso and head could also suggest a smaller species with long wings, like a swallow or swift. Their claws grasp a (*shen-*?) ring (a flat base is not visible). Contrary to other elements of the decoration, the glass inlays of their bodies are not flat, but worked in relief. (b) A very unusual palmette is represented on each side of the pommel; no Egyptian parallel is known to us.

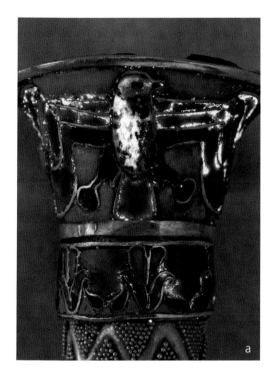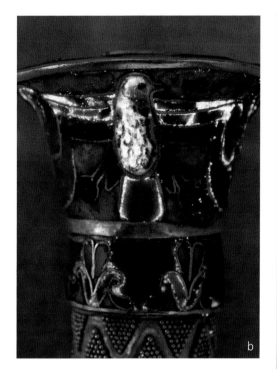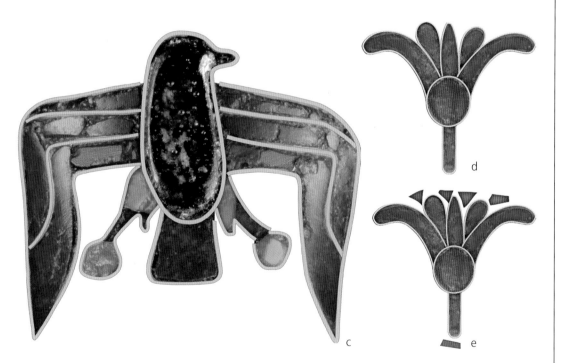

**Fig. 30** (a and b) Small things can often surprise. Near infrared imaging reveals that the two small transparent glass inlays of birds on the pommel of the golden dagger were painted on their underside with the bird's eye and feathers. (c) Color reconstruction of the bird inlays. The color of the background is so degraded it cannot be determined, but it might have been red or yellow glass. The colors of the painted decoration, which was originally more clearly visible through the glass, also cannot be determined at present. It is likely that the eye was painted black and the feathers may have been detailed in blue. (d and e) Color reconstructions of the palmette motif. The original color of the circular element in the center of the palmette can no longer be identified. It could have been (a now severely disintegrated) blue or yellow. If the entire background was once yellow (rather than red), the well-preserved opaque red inlays above and below the palmette would have been part of the motif.

Simply the very best—the golden dagger and sheath

**Fig. 31** (a) Top surface of the pommel, representing an elaborate rosette with papyrus and lily flowers in the guilloche style. In its center, but not oriented along its central axis, there is a double cartouche whose execution is comparatively rough. (b and c) Possible color reconstructions of the rosette motif. The color that was used for the sepals of the papyrus umbel could no longer be identified. The upper part of the papyrus-like topping of the lilies could have been yellowish, possibly also red, in accordance with the color scheme displayed on the sides of the pommel.

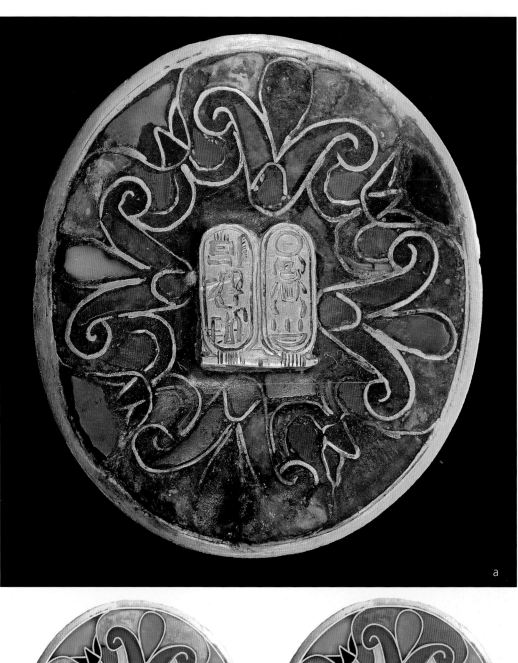

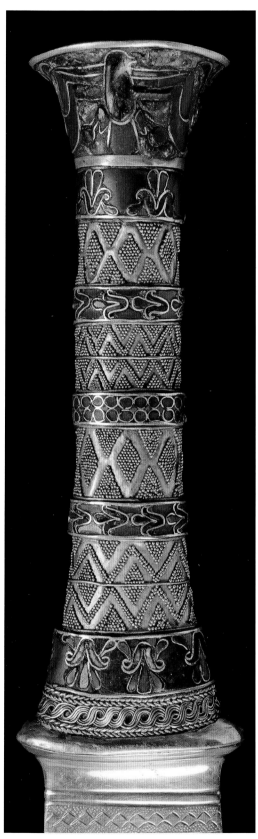

**Fig. 32** Front view of the handle: pommel and hilt fit harmoniously.

**Zone 1** (from the top): The zone just below the pommel consists of a frieze with lily-palmettes. They are orientated toward the pommel and decorated with inlays of red and blue glass. Inlays of lapis lazuli were used for the background of the motif.

**Zone 2**, below, is ornamented with gold granules and is delimited above and below (as is also the case with all the other zones that are entirely decorated with gold) by a filigree wire soldered onto the surface. Granulated diamond shapes, positioned in a central row, are separated from one another by pairs of upward- and downward-pointing granulated triangles. The triangles are made of between thirty-six and forty-six granules each; the diamonds of about forty-eight to fifty-five granules (see Fig. 33).

**Zone 3** shows a frieze with lilies—this time, opening toward the left. The floral leaves are inlaid with lapis lazuli and feldspar.

**Zone 4** is divided into two halves by a filigree wire that runs through its center. From top to bottom, each half is decorated with a row of granulated triangles pointing down, a double zigzag line, and a row of granulated triangles pointing up. Here, the triangles consist of fifteen granules each.

The design of **Zone 5** is unique. It consists of a frieze of two rows of circular compartments, in which blue and red glass inlays or (minor quality) carnelian or quartz slices on a colored background alternate. The spaces between the circles are inlaid with turquoise glass, although these inlays have now been partially lost.

**Zone 6** corresponds to Zone 2. The triangles consist of between fifty-five and sixty-three granules each; the diamonds of between sixty-four and sixty-eight granules.

**Zone 7** corresponds to Zone 3. In the detailed photograph (Fig. 34), it is obvious that the gold used here is of a different composition from that employed for the decoration of the handle: the gold elements delimiting the compartmental inlays generally show a more yellowish color, whereas the neighboring zones with the granule ornamentation exhibit a different, often more reddish-gold hue. Note that the surface is extensively covered by recent wax and dust.

**Zone 8** corresponds to Zone 4: the triangles are made of about twenty-eight to thirty-six granules each (see Fig. 35).

The motif of **Zone 9** resembles that of Zone 1. However, the flower or palmette is more opulent and opens toward the blade. A filigree gold band was soldered onto the lower edge of the frieze: two cords, each consisting of two wires that were plied or twisted together—one in an S-twist, the other in a Z-twist—form the upper and lower edges of this gold zone. They create a herringbone pattern with acute angles. The circumferential rope-like band is itself made of two strands twisted together, each of which consists of four flat and parallel wires (see Fig. 36).

**Fig. 33** In Zones 2 and 6 the gold sheet under the small granulated diamonds and triangles is slightly flattened. The sheet may be thinner in these areas, so it was deformed by external pressure.

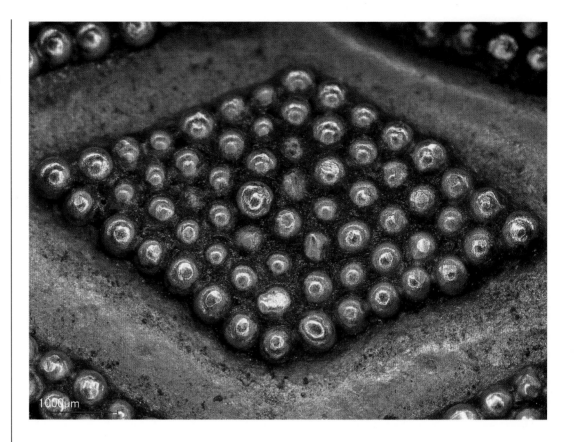

**Fig. 34** Detail of decorative Zone 7: lilies opening toward the left. The colored material used to fix the inlays (here, possibly colored with orpiment) is easy to see.

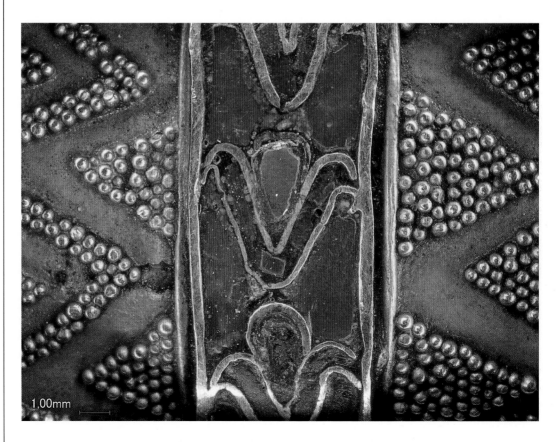

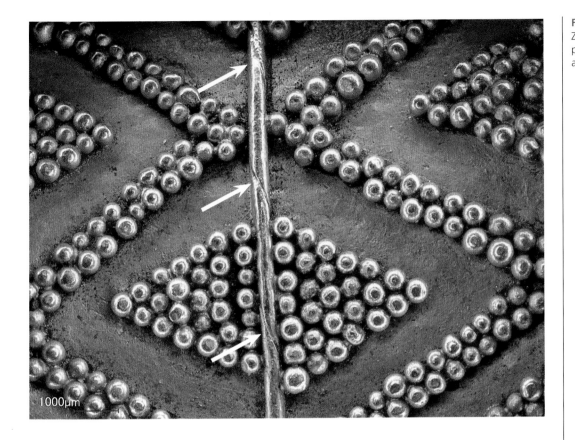

**Fig. 35** Detail of decorative Zone 8: the round wire was probably produced by twisting a thin strip of gold foil.

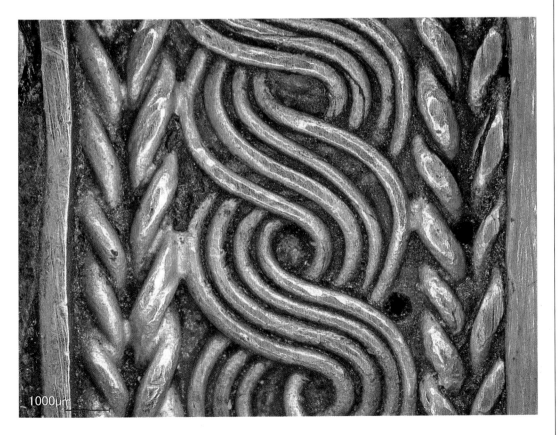

**Fig. 36** Filigree bands decorating the lower edge of the handle. In the middle, a rope-like band made of two strands of four flat parallel wires.

**Fig. 37** The surface of the golden dagger is nicely smoothed and polished. Only a few marks from the polishing process are discernable along its blade. Both edges are beveled.

**Fig. 38** X-ray image: the tang of the gold blade differs slightly in shape from that of the iron dagger. The lower edge of the pommel is elongated to fit under the hilt cover made of gold.

The symmetrical, slightly convex blade with its pointed tip has a flat, lenticular cross-section (Fig. 37). A decorative frieze of diamonds, with tiny dots marking the background, runs horizontally just below the clamp. It is flanked by simple, circumferential bands; the lines framing the one on top are deeply chased into the metal, the lines for the lower band more shallowly (see Fig. 28). A volute plant with inflorescences opens toward the handle, crowning a shallow central rib that runs down the length of the blade, framed on each side by another fine line.

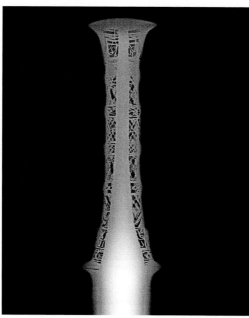

The X-ray images show that the gold blade, like the iron dagger blade, terminates in an elongated tang (Fig. 38).[78] The tang of the gold blade, however, was probably fixed to the hilt by a rivet that pierces the pommel, with the cartouches on top of the pommel being the rivet's head.[79]

### The sheath

The sheath, which is elaborately decorated on both sides, consists of two gold sheets that are held together by a piece of sheet gold that is U-shaped in cross-section and surrounds the case on two sides (Fig. 39). Small strips of gold sheet were placed at irregular intervals and used in soldering the edging onto the main body of the sheath (Fig. 40; see also Fig. 44b). We cannot tell whether the two sides of the sheath were additionally soldered together beneath the edging or whether they are merely joined by crimping.

The side of the sheath that faced upward when found[80] (see Fig. 27a) is decorated with a feather or scale pattern in compartmental inlay technique. This motif was created not only by soldering the small strips of gold sheet that form the inlay compartments onto the base, but also by placing a tiny tongue-shaped gold piece onto one of the compartments that made up each feather or scale (Fig. 41).[81] This variation of compartmental inlay decoration is relatively unusual, but is also used in a few other objects from Tutankhamun's tomb. The feathers or scales are oriented toward the opening of the sheath, where there is a frieze of lily-palmettes, which resembles the palmette frieze of Zone 9 of this dagger's handle, save for minor variations in the color scheme. The tip of the sheath is decorated with a canine head, which—unlike that of the iron dagger—was made by chasing (repoussé) with details added from the front (Fig. 42a and b).

The other side of the sheath shows a framed depiction of animal fight scenes stacked along the vertical axis of the sheath (Fig. 43); a volute plant fills the entire space of the tip. The top part of the sheath is decorated with a horizontal inscription with the throne name of Tutankhamun, below a frieze of S-twisted spirals (meander). Two small lily-shaped loops of gold wire are soldered onto the sheath in order to facilitate its attachment or suspension.[82]

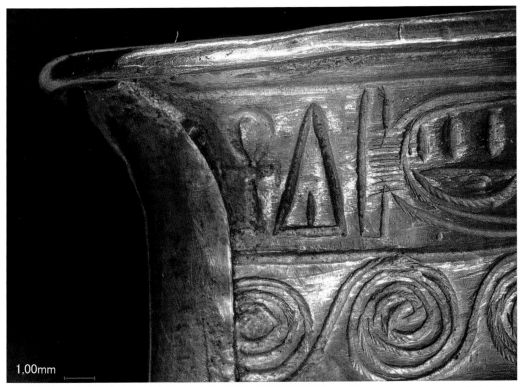

**Fig. 39** The outside edge of the sheath is made of a strip of gold sheet, with a U-shaped cross section that joins the two halves of the sheath together. The inscription and the running spiral band were chased into the sheet.

**Fig. 40** Close-up of the small, diagonally arranged strips of gold sheet by means of which the U-shaped framing edge was soldered onto the sheath halves (see also Fig. 43b).

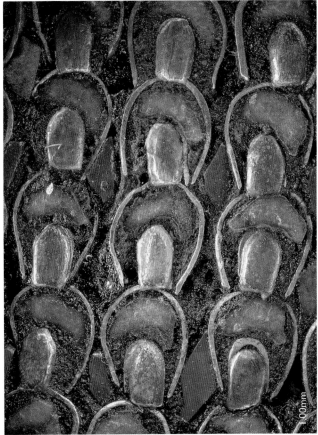

**Fig. 41** The feather or scale pattern includes small tongue-shaped gold pieces placed on top of some of the gold sheet compartments.

Simply the very best—the golden dagger and sheath   43

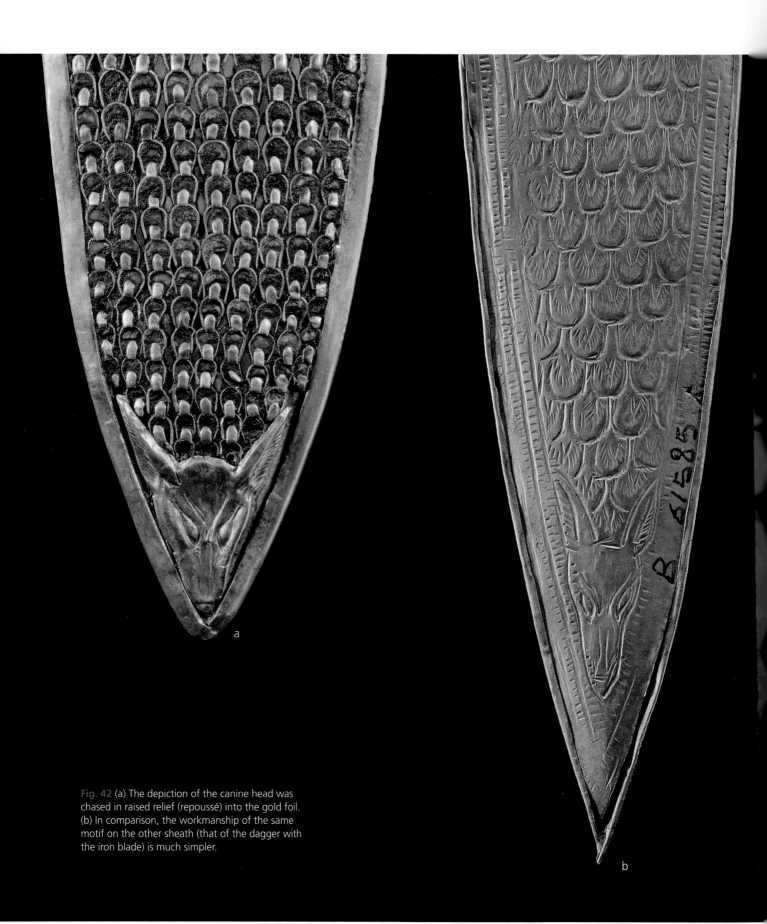

Fig. 42 (a) The depiction of the canine head was chased in raised relief (repoussé) into the gold foil. (b) In comparison, the workmanship of the same motif on the other sheath (that of the dagger with the iron blade) is much simpler.

Even though the animal-fight scene decorates the back of the sheath, Carter believed that it was more significant than the feather or scale pattern. The imagery led him to suggest that this dagger was used as a hunting knife. He emphasized the fact that "the scene . . ., like the whole scheme of decoration upon the dagger and sheath, suggests affinity to the art of the Aegean or Mediterranean islands." Based on other factors, he concluded, however, that the craftsman must have been an Egyptian: "the handiwork of an Egyptian and not of an alien, whatever the influence might be" (Carter 1927, 132–33) (Fig. 44a and b).[83] Feldman refers to the sheath, with its animal fighting scenes and volute plants, as a representative par excellence of the so-called "International Style," providing "a general and generalized statement of kingship" (Feldmann 2006, 13, 31). These objects were popular among the elites of the late Bronze Age Eastern Mediterranean, comprising a clear, easily recognizable message of the power and cosmopolitan nature of their owners. The questions remain open as to whether International Style objects were produced in one location and traded—and whether as diplomatic gifts or luxury exports, whether groups of itinerant craftsmen produced goods at different centers, or whether local craftsmen were versed in this style.

Regardless of these questions, this scene is undoubtedly one of the finest late Bronze Age repoussé works found in Egypt!

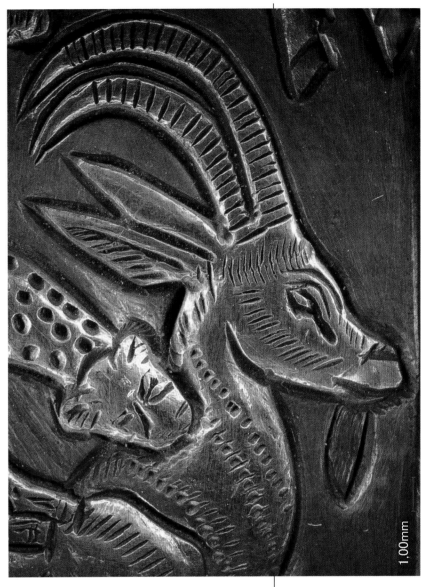

**Fig. 43** Detail of the exquisite animal fight scene found on the sheath of the dagger: a leopard pounces on an ibex and attacks its neck. The motif was chased in raised relief (repoussé) into the gold foil. Afterward, some areas were masterfully highlighted by adding punched dots and squares as well as finely chased lines.

The gold used for the sheath consists of 87.5 wt% gold, 10.9 wt% silver, and 1.14 wt% copper. An analysis of the clamp section shows that its composition clearly differs from that of the blade, which also explains the obvious difference in color. The latter is made of an alloy comprising 88.1 wt% gold, 5.3 wt% silver, and 6.8 wt% copper, and thus also diverges from the material composition of the sheath.

The analytical data for the blade reveals a composition that lies far beyond the calibrated range, such that the measurement is not quantifiable. Based on the spectrum, however, it can be assumed that the alloy contains nearly equal parts of gold and copper. The silver content of the alloy is less than 3 wt% (regarding the methodology, see pages 27 and 30).

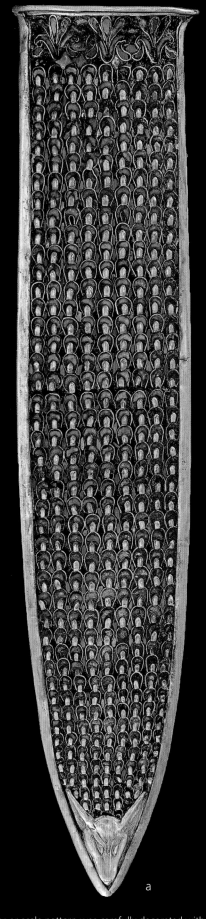
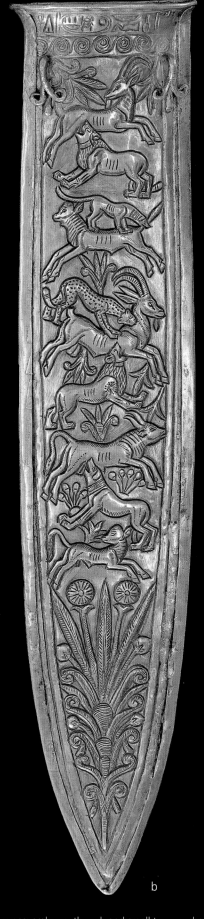

**Fig. 44** (a) The feather or scale pattern was carefully decorated with inlays of dark-blue glass, which are now severely weathered, and small tongue-shaped gold appliques. The background shows alternating rows of light-blue—or, rather, turquoise—and red glass inlays. Along the upper edge, there is a palmette frieze displaying the same color combination. Thus, contrary to what its current state might suggest, blues once dominated the motif of this sheath side (see also Fig. 41); 21 cm x 4.4 cm (L. x W.). (b) In an elaborate arrangement, hunting animals (lions, dogs, and a leopard) chase and attack prey (ibexes, calves, and a bull). Following the principle of *horror vacui*, volute-like plants fill the spaces between them. The spiral frieze and the inscription below the top were only shallowly chased into the material, and the text is slightly shifted to the left (see also Fig. 39).

## The golden dagger—"twin" or "elective affinity"?

The two daggers of Tutankhamun are both outstanding and unique. The similarities in their manufacture—each consists of a blade with an elongated narrow tang and has a separately made pommel—as well as the use of similar decoration techniques and shapes for the design of the hilt make them seem a pair. At first glance, one could even call them twins. However, striking differences in the quality of their execution render such a judgment doubtful.

In the case of the golden dagger—besides the use of a gold blade and the production of a pommel that correlates with the handle decoration—the presence of Tutankhamun's name on the pommel and the sheath represent, of course, the most obvious difference. Moreover, the excellent quality of the compartmental inlay technique stands out in comparison with its iron counterpart (Fig. 45a and b). The inlays are executed far more precisely; in some cases, segments of thin glass rods were also used as inlays. Furthermore, the layout of the compartments is markedly more elegant and the motif with the alternating papyrus and lily flowers on the top of the pommel is particularly noteworthy. The accuracy of the granulation work found on the decoration of the hilt differs as well: the granules were produced or chosen more carefully, and grouped precisely in large numbers to form elaborate patterns (Fig. 46a and b).

When it comes to the sheaths, the skillful repoussé work representing a wonderful animal fight scene competes with a simple, chased palmette decoration. The image layout on their other sides presents a similar scenario: an elaborate feather or scale decoration, produced in a complex variation of the compartmental inlay technique, stands in opposition to a simpler chased feather pattern.

Despite the unique choice of its spectacular iron blade, as well as the prestigious and perfectly symmetrical rock-crystal pommel, the dagger with the iron blade should be regarded as the "little brother" of these two. Based on these observations, it is hard to imagine that the two daggers could have been produced by the same craftsman. However, production in the same workshop or workshop group cannot be excluded.

It is clear that these differences evoke divergent ideas and constitute an intriguing logistic puzzle—especially when taking into account the geographical perspective, Egypt's political and economic contacts during the New Kingdom, and the stylistic influences of neighboring nations and immigrant craftsmen. Considering the technology transfer of this period, the example of the granulation technique is of particular interest. It is of Mesopotamian origin, but subsequently spread across the Levant into Egypt, and by Tutankhamun's reign at the end of the late Bronze Age it already formed part of Egypt's own traditional skills.

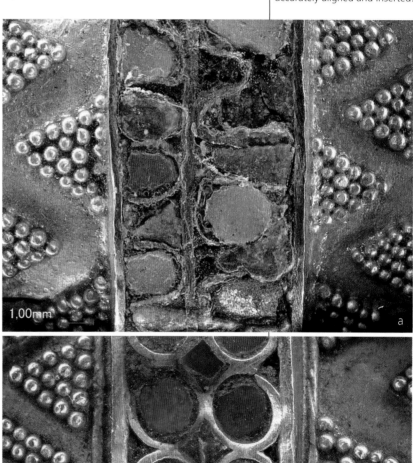

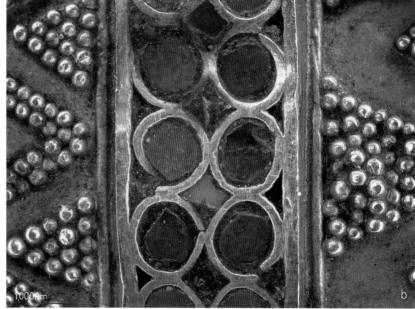

Fig. 45 *Pars pro toto:* comparing two decorative zones in the middle of the handles: (a) the dagger with the iron blade; (b) the dagger with the gold blade. In the latter case, the compartments are much more precisely made and the inlays are executed more accurately and thus fit better. The pictures in comparison speak for themselves: in (b), the cells are much more precisely arranged, and the inlays are more accurately aligned and inserted.

**Fig. 46** The granulation on the two daggers also shows considerable differences in quality. (a) For the dagger with the iron blade, granules of different sizes were used and arranged into geometric patterns rather imprecisely. The line of granulation placed on the two strands of round wire has been almost completely lost here. (b) For the gold dagger, the granules are of a more consistent size and shape, and are more carefully assembled into regular geometric patterns with identical numbers of granules in each triangle

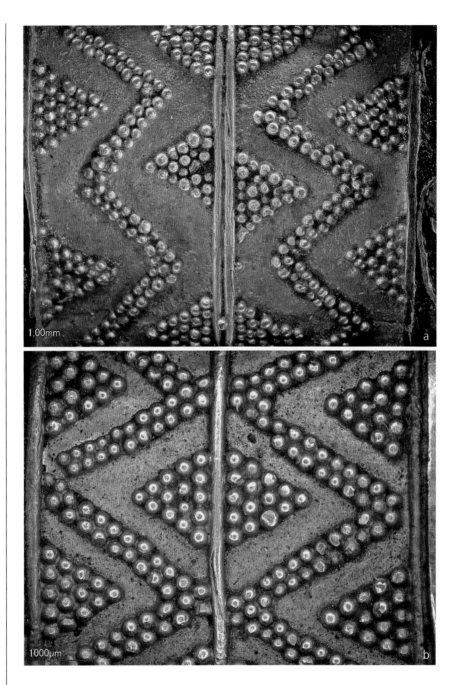

One can propose that every component of the two daggers—handles, blades, and sheaths—could have been produced at different times and/or in different places. Likewise, the materials employed, as well as semi-finished products such as preformed gold sheets or models of different origins, may also derive from a variety of sources. Bearing all this in mind, one could expand these theories nearly indefinitely and pursue them more widely. These considerations are ultimately only speculative, and in fact raise more questions than they can actually answer. The last word can remain with Johann Wolfgang von Goethe:

Das schönste Glück des denkenden Menschen ist es, das Erforschliche erforscht zu haben und das Unerforschte ruhig zu verehren.

(The most beautiful delight of the thinker is to have researched the researchable and silently to revere the unresearchable.)
Johann Wolfgang von Goethe

# Notes

1 For a recent introduction to the topic, see Scalf 2017.

2 On this topic, see, for example, Beinlich 2006, 17–31. For the depictions in New Kingdom private tombs, see also Wohlfarth 2005.

3 During the excavation of the tomb, Carter allocated (in theory) every object a unique reference number, based on a series running from 1 to 620, which were further subdivided with letters in the case of any objects found inside the object, e.g. a box or a casket. The excavation records include object cards, photographs, and conservation notes made by Carter and his collaborators. Using these objects' Carter numbers or Card/Transcription numbers, almost all objects from the tomb can be searched for in the extensive Tutankhamun database of the Griffith Institute, University of Oxford: http://www.griffith.ox.ac.uk/discoveringTut/

4 Carter called it *udjat* in one case and *wedjat* in another (see Card/Transcription no. 256hh–1 and also note 12).

5 Carter suggested that the chest had originally also contained four metal and wood lamps (Carter no. 41a–d) that he found in the antechamber of the tomb (Carter 1933, 93–94).

6 See also Lucas and Harris 1962, 239. Already by the time of the Old Kingdom, coniferous wood was one of the most important trade goods and was imported from Lebanon (Helck 1975, 120).

7 It was not possible to micro- and macroscopically analyze the iron tips in more detail. Due to the corrosion deposits, traces of use and abrasions were not discernible with the naked eye.

8 For a detailed and clear study on the topic see Assmann 2001, 408ff; for a discussion of the statue rite, see Clark 2003, 331ff.

9 Wainwright himself addressed this discrepancy (Wainwright 1932, 15). Although other materials were used in the production of the tools for want of iron, he thought that the texts might still refer to *bia* (which he interpreted as iron) in order not to compromise or even lose their magical effect. Graefe, on the other hand, did not interpret the term *bia* (according to Graefe: meteoritic origin) as a designation for a clearly defined material and assumed that it might rather have referred to flint, to which a meteoritic origin was likewise attributed in early dynastic times (Graefe 1971).

10 Alfred Lucas' notes on conservation of objects from the tomb of Tutankhamun, Seasons 1926–7 and 1927–8: http://www.griffith.ox.ac.uk/discoveringTut/conservation/4lucasn5.html

11 During the attempt to correlate individual chisels with their Carter numbers, inconsistencies arose. The reason for this could be an incorrect concordance with the Egyptian Museum's *Journal d'Entrée* (JE) numbers or, since three tips had fallen out of their handles in the tomb (others possibly at a later date), the loose tips may have been reattached to the wrong handles. The graphic representation of the chisels (Fig. 6) is thus intended to illustrate the variety of forms taken by metal tips and wooden handles, but slight deviations in proportions as well as a possibly incorrect association with Carter's numbering cannot be completely excluded.

12 Salima Ikram and Tom Hardwick have indicated that the terms *wedjat* and *udjat* are used interchangeably by Egyptologists due to different conventions of transcription of the Egyptian word *wḏ3t*, and do not indicate either the right or left eye of the god. This contradicts our use of the terms in the German edition of this book (Broschat et al., 2018). Since both terms are used in Egyptological texts, it was not apparent to us that, although the right and left eyes represent different concepts and myths, both seem to be called either *wedjat* or *udjat*

(sometimes even *wadjet*) rather randomly, without referring to the different respective meanings of the two eyes. Certain authors seem to indicate that *udjat* was the term for amulets which used the (left) Eye of Horus motif (c.f. Bongioanni and Croce 2003, 622). However, we believe that this amulet was made purposefully in a way that allowed the owner to deliberately choose whether to wear it as a right or left eye. Following this hypothesis, we concluded a meaningful difference in these two terms, which would appear plausible in light of the discussions of Bonnet 1952, 314–15; 854–56, von Lieven 2007, 193 and (obviously following von Lieven) Graf 2012, 28. For a general discussion of the various Egyptian myths regarding divine eyes, see also Andrews 1994, 43–44.

13 The term right or left eye is used as "proper" left or right.

14 Repoussé work or repoussage refers to the technique of shaping a gold sheet by hammering or chasing from the reverse, creating decoration in raised relief. In brief, this was done by using a hammer repeatedly to drive larger punches of different shapes into the metal. In general, dictionary definitions of several terms commonly used in English (chasing, embossing, chiseling and engraving; see e.g. OED Online, Oxford University Press, https://www.oed.com) actually describe what we consider different techniques (they include separate reshaping and chipping/cutting techniques together); these terms are also used inconsistently by scholars. Here, we use "chasing (repoussé)" to describe specifically the action that is used to create a repoussé work, a raised relief worked from the reverse and supposed to be seen from the front. "Chasing," on its own, is used to refer to the action used to decorate gold from the obverse, to draw, for example, narrow lines or dots (see also note 41), which is technically the same process, but uses smaller punches. In addition, it is used to define the outlines of a motif in a repoussé work. Note that both methods (as we describe them) do not remove any gold, but simply displace and reshape the metal.

15 This is the only technique among the objects studied here where metal is removed to render a decorative detail or motif.

16 Alfred Lucas' notes on conservation of objects from the tomb of Tutankhamun, Season 1925–26: http://www.griffith.ox.ac.uk/discoveringTut/conservation/4lucasn4.html

17 Carter Journal, 18/11/1025; Card/Transcription no. 256–4v.

18 This detached placement of the headrest inside the mask led Desroches-Noblecourt (1963, 235) to the assumption that it was positioned here as the last act of the preparation of the mummy.

19 During the Eighteenth Dynasty, hematite was probably obtained from the Sinai peninsula or the Aswan region (Aston, Harrel, and Shaw 2000, 38).

20 Card/Transcription no. 256–4v. See also Lucas and Harris 1962, 239.

21 Card/Transcription no. 256–4v.

22 Tutankhamun's glass headrests (Carter no. 403a and TR 2/3/60/1 [temporary register EMC]) impressively demonstrate that even faulty and "repaired" artifacts were still fit for a king. For the studies conducted on this topic, see Broschat and Rehren 2017 and Broschat, Rehren, and Eckmann 2016.

23 Many of Tutankhamun's inlaid objects are often (mistakenly) termed cloisonné, which is a technical term referring to a type of vitreous enamel technique. In cloisonné, "a line drawing of the motif was created by means of a delicate network of fine gold bars fixed to the surface and the individual compartments of this drawing were filled with colorful enamels" (author's translation of Woermann 1905, 72). In this book we will use the term "compartmental inlay technique" as the material is not enamel, but separately manufactured inlays of glass and colorful stones.

24 Vogelsang-Eastwood criticized the fact that only a few researchers differentiate properly between "apron" and "kilt" (Vogelsang-Eastwood 1993, 32). During our research, we did not encounter agreement between scholars in the terms they use to describe aprons, kilts, and other decorative elements, either. According to Vogelsang-Eastwood, an apron could be made of cloth or leather, to which ornamental jewelry components were added. In this case, the object in question must be

one of these; in this book we will use the customary term "apron."

25. Carter also noted, "*Uraeus Buto Insignia* (of Diadem 256, 4, O) was placed as counterbalance to dagger 256, K" (Card/Transcription no. 256r–1), but we believe that the arrangement of the two insignia to the right and the left of the "apron" was more significant.

26. Carter no. 256l. Carter calls it a girdle. It might also have been used to keep the apron in place.

27. Carter no. 256eee, the other was too decayed to be recovered and did not get a number (Carter 1927, 134). Carter did not know which tail belonged to the belt.

28. See Burton photo no. p0793.

29. Petschel 2011, 212, 482–83. A characteristic of this dagger type is its thick-walled handle construction consisting of a hilt that was partially cast hollow (orig: "teilweise hohl gegossenen Griffstange") and had a tenon for the pommel.

30. For more information on rock crystal in Egypt, see Lucas and Harris 1962, 63, 402–403; Aston, Harrel, and Shaw 2000, 52. The large-scale production of rock-crystal pommels is also known from Minoan Crete: "The Minoans also made extensive use of rock crystal . . . large number[s] of extant armlets, pommels and pendants, indicate that rock crystal was used for a wide variety of luxury goods" (Rapp 2009, 138).

31. When this study was conducted, only three pins kept the pommel in place. It is not entirely clear from Burton's photographs whether the fourth pin was already missing at the time of the discovery.

32. Petschel describes the basic form of the pommel as cylindrical. However, we did not see a significant difference in shape between this example and, for instance, the dagger pommel with the cartouche of Ahmose I (Royal Ontario Museum, Toronto; see Petschel 2011, 478), which she classified as cup-shaped (see also note 79). Apart from that, it recalls a papyrus or lily flower, Egyptian symbols of rebirth and resurrection.

33. The gold covering of the hilt might actually consist of several different segments of almost cylindrically formed gold sheets that were slid one by one over the core of the handle. Notably, the hitherto misunderstood construction of the handle (see note 29) should be revised and its typological classification—if necessary—corrected.

34. For a detailed discussion on filigree and filigree wireworks, see Wolters 1985. See also, for example, Oddy 1977, 84–86.

35. Granulation developed in the Near East in the mid-third millennium BC. In Egypt, the earliest attested granulation work probably occurs on Princess Khnumet's jewelry (approximately nineteenth century BC), although some scholars suggested these were eastern Mediterranean, Cretan–Anatolian imports (Lilyquist 1993, 36-37). Wilde suspects that there was no direct adaptation of the granulation technique in connection with foreign forms from the Near Eastern region but rather "an inspiration received through foreign contacts, subsequently transferred onto local goods" (author's translation of Wilde 2013, 129). For granulation, see also Ogden 2000, 165; Wolters 1983; Saretta 2016, note 207.

36. Unlike the granulation technique, the compartmental-inlay technique appears to originate in Egypt. It points to "an impulse from Egypt wherein Egyptian finds also provide evidence for the individual development stages of this technique" (author's translation of Wilde 2013, 129, for a full discussion see Wilde 2011, 231). "The nature and extent of the possible transfer routes that have led to the adaption of granulation (see note 35) and might have led to the development of the compartmental inlay technique throughout the Levant cannot be narrowed down at this stage" (Wilde 2013, 137).

37. This decoration is attested since the second half of the second millennium BC in Cyprus and Egypt (Wolters 2014).

38. This also applies to all the other decorative zones with their colorful inlays that are described.

39. A detailed discussion on this topic is found in Eckmann's publication on Tutankhamun's mask (Eckmann, forthcoming). For the appreciation of colored glass in the late Bronze Age, see also Shortland 2012, 17.

40 Other than describing the creation of a repoussé work (see note 14), the term chasing also refers to the technique of decorating gold from the obverse. To push the metal, one can use, for example, a small punch that has a flattened tip with a slightly curved blunt edge to draw narrow lines or grooves, or punches that have round-, oval-, or square-shaped tips of small diameter to create dots and dimples. Again, this decoration method does not remove the metal and only reshapes it.

41 The same also applies to other materials that are mentioned in the context of "extraterrestrial origin," like the scarab carved from Libyan Desert Glass and inserted into one of Tutankhamun's breast ornaments (Carter no. 267d; de Michele 1998).

42 When it comes to archaeological finds of iron that are older than the first evidence for iron smelting, it has often been assumed that this iron might actually be a by-product of copper smelting. However, this thesis was refuted by Merkel and Barrett (Merkel and Barrett 2000).

43 Roberts, Thornton, and Pigott 2009, 1019. This statement relates to the development of metallurgy in Eurasia. Stevenson argues that unusual materials particularly fascinated the ancient Egyptians because of their exceptional colors and textures (Stevenson 2009, 186).

44 Find number A1.K.14, Koşay 1938; Nakai et al. 2008, 322. For a more up-to-date and detailed description as well as discussion of these early iron finds, see Pare 2017, 14–22.

45 Here, we would like to sincerely thank Andreas Effland, who drew our attention to this interesting discovery.

46 We are not aware of any scientific analysis conducted on these meteorites, nor their current location.

47 In a letter, the offer of eight shekels of gold for a single shekel of iron was rejected for being inadequate (Maxwell-Hyslop 1972, 159–62).

48 Note that copper in Egypt often contained natural arsenic and was therefore particularly hard.

49 For the gift list, see also the more recent study on the Amarna correspondence by Rainey (2015, 163ff).

50 Telluric iron in usable quantities mainly occurs in western Greenland (Disko Island) and in Russia (Khuntukun massif), and the earliest objects known to be made from it date to AD 700 and are of Inuit manufacture (Buchwald 1992, 146–152; 2005, 19–20). There are two types of telluric iron (Buchwald 1992, 155). Type I corresponds to a non-processed cast iron. It has a carbon content of over 1.5 percent and a nickel content of up to 4 percent. Type II is characterized by a carbon content of less than 0.2 percent (nickel < 4 percent) and a very good cold formability. It is found as small, maximum pea-sized, inclusions in basalt (Buchwald 1992, 145–46). Man-made iron alloys containing nickel can also be produced through the smelting of nickel laterites that occur, for instance, in Greece. However, to our knowledge, this method is only attested once in the archaeological context (Adam-Velini 1988, 39; Photos 1989, 411 et seq.). In a Hellenistic settlement close to Petres (northwestern Greece, near Florina), smithing slags and bloom fragments that partially display high nickel contents were excavated (Photos 1989, 411). So far, there are no studies that could link a specific archaeological object to this deposit.

51 In one Hittite text, the sky itself is designated as iron: [AN.B] AR—*nepis*, "sky of iron" (Reiter 1997, 395–96).

52 A slightly older yet likewise clear and detailed discussion is also found in Amborn (1976, 59–63). Crucial, and thus certainly also causative for the disagreement on the meaning of the term, are the (inevitably) etic approach and the attempt to harmonize the modern, abstract neologisms and the multifaceted, often rather descriptive, terminology of the ancient Egyptians. In a different context, Schäfer (1963, 37) gets to the heart of it "without taking into account the fact that we apply a term from modern jargon onto the Egyptian way of thinking, even though the concept is still foreign to it."

53 ". . . Erhart Graefe's dissertation [traces] the origins and use of the word *bj3* [bia] with the meaning 'star material', initially designating copper ore in the Old Kingdom, then

bronze, and finally, in the New Kingdom, with the added specification *n pt* for iron" (Eaton-Krauss 2016, 32). Unfortunately, we have not been able to access this dissertation (Graefe 1971).

54 The nickel content is often regarded as sufficient proof for meteoritic iron, but nickel can occur in iron from different sources like telluric iron (see note 50).

55 Overall, the following groups are distinguished: IAB, IC, IIAB, IIC, IIE, IIF, IIG, IIIAB, IIICD, IIIE, IIIF, IVA, and IVB (as well as the "ungrouped") (Buchwald 1975, 60).

56 For warm deformation of the iron, it is not necessary to reach the melting point of iron or to have any specialist knowledge about iron smelting—only good craftsmen are needed!

57 As it is impossible to polish and etch any of the iron objects from Tutankhamun's tomb or even to take a sample, only the option of an RDA mapping with a simultaneous microanalysis would potentially identify taenite and kamacite lamellae (Buchwald 1992, 147; 2005, 25–26).

58 This was shown by, amongst others, Buchwald 1992, 152 et seq., who cold-worked a part of the Cape York meteorite as well as a piece of modern steel (St 42-B) into axes. In comparison with the reference steel, this deformation did not lead to any significant hardening of the meteoritic iron. This was due to the already-present structure (Widmanstätten pattern) of the meteorite used. In the case of the meteorite, as well as that of the comparative piece, annealing increased the ductility of the structure and decreased its hardness by about 50 percent on the Vickers hardness scale. The experiment therefore showed that it was possible to reduce the initial thickness of the Cape York material by over 80 percent without any significant crack formation, even without intermediate annealing (Buchwald 1992, 153). Non-invasive analyses certainly cannot help in clarifying the question of how an artifact of meteorite iron was produced, unless the craftsmen did not apply any surface-treatment techniques after shaping the object. However, to our knowledge, this manufacturing type is only attested once in the archaeological context—namely, in the case of the meteoritic iron blades of the Inuit that date to the period of about 700–1850 CE (Buchwald 1992, 141–42).

59 Following her experiment, Johnson notes, "using modern grinding technology was comparatively rapid" (Johnson and Tyldesley 2016, 415). In this context, it should be noted that there are only minor differences between these easy, modern grinding methods and the corresponding ancient techniques.

60 Due to the only minimally corroded surface of the blade ("a few rust spots"; Card/Transcription no. 256k–1), Carter concluded "resembling steel!" (Carter 1927, 135).

61 Unfortunately, the authors do not reveal the measuring method employed, so the results cannot be fully comprehended, nor included in this study.

62 Only the values for nickel obtained during this investigation deviate significantly from our own findings. Our analyses of the iron dagger were also presented in 2016: Ströbele et al. 2016a; 2016b, 189.

63 Meteorites of the following collections were used: Braunau, Chinga, Prambanan: Natural History Museum in Vienna; Boguslavka, Calico Rock, Hoba, Lombard, Santa Clara, Skookum and Tlacotepec: Senckenberg Research Institute and Nature Museum in Frankfurt am Main.

64 However, a nickel loss of 21 percent rel.—which has, for instance, been calculated for meteorite objects that were completely transformed by soil corrosion (Buchwald 2005, 28 et seq.)—is rather unlikely in this case, as the artifacts were kept in an otherwise empty wooden chest. The example quoted here refers to the Boxhole meteorite, which has a nickel content of 6.03 wt% and thus differs from the composition of the iron tools. It should merely illustrate the expected range.

65 See note 16.

66 In order to clarify this issue, a space-resolved alloy or phase analysis would be necessary.

67 Not all the measurement points yielded chromium.

68 The soldered joint is only between 0.5 and 1.6 mm wide, and is thus far smaller than the measurement point itself.

69  Our findings have been subsequently confirmed by an independent critical assessment of our data, which compared it with that from other meteorites (Jambon 2017, 50).

70  Even in a corroded state, some of the al-Gerzeh beads, made of hammered meteorite iron, contain traces of germanium (Rehren et al. 2013, 4789).

71  In this case, only the dagger, bracelet, and headrest. The chisel tips were excluded here because their composition could not be determined conclusively due to their state of preservation.

72  If the foam-like structures described in the caption accompanying Figures 8a–d developed in the context of a special corrosion form, this could possibly be interpreted as an indication for this last-mentioned process.

73  It cannot be established which animal's tail was originally attached to this girdle (see also note 27). For the dagger and the girdle as parts of the so-called Lower Egyptian costume see Hellinckx, 1997.

74  A similar motif—a falcon with outspread wings, the tips of which are strongly bent downward, holding a *shen*-ring in its claws, and its head turned toward the right—is attested on the pommel of two wooden dagger grips naming the earlier Eighteenth Dynasty king Thutmose I; Metropolitan Museum 22.3.75a, b (Roth 2005, 15).

75  Similar inlays are, for instance, found on the uraeus-snake of Tutankhamun's funerary mask and one of his chariots (Carter no. 122).

76  This does not seem to be a preliminary drawing for the cartouches, but, rather, traces of earlier work, perhaps with a different motif. Petschel does not recognize any signs for a (politically motivated) name change on the pommel, and thus believes that the dagger (and the sheath) were only produced after the king's name changed from Tutankhaten to Tutankhamun (Petschel 2011, 215). We are not aware of any published discussion about the later insertion of these cartouches or a name change that would indicate an earlier owner of the dagger. Because of the unsymmetrical, and hence slightly irritating, placement of the cartouches, as well as the obviously inferior quality of their craftsmanship, we suggest that the central zone on top of the pommel was originally decorated with a different motif. However, we cannot say whether this (possible) earlier decoration was another cartouche or an ornament related to the floral elements. The inscription on the sheath also shows several distinctive traces (see figs. 39; 44b).

77  Petschel describes the hilt as a thick-walled handle with some hollow cast parts (orig. "massivwandig mit teilweise hohl gegossener Griffkonstruktion") and a tenon for the pommel, and attributes it, like the iron dagger, to Type VII of her typology. However, this typological classification should be revised from an archaeological point of view. It was impossible to determine whether the gold sheets of the hilt are individual segments.

78  Petschel noted several similarities between this dagger and the more-or-less contemporaneous blades from Tell al-Ajjul and Safed (Petschel 2011, 213, with fig. 43 showing the drawing of the two aforementioned blades from Shalev 2004, pl. 12). She assumed that the handle pieces and sheaths of Tutankhamun's two daggers were produced in the same workshop as the gold blade. For the iron blade, she suggests production in the Near East (Petschel 2011, 214).

79  A different means of attaching the tang to the hilt is hard to imagine. This same method of attachment could also have been used for the dagger with the cartouche of Ahmose I from the Royal Ontario Museum (note 32), although that dagger most probably does not consist of a blade with a tang. Heinrich (1963, 14) notes that the pommel of the Ahmose dagger was fixed by three rivets with rosette heads. However, this does not rule out the possibility that the cartouche decorates, and thus hides, the head of a fourth rivet.

80  In this case, we can distinguish front and back because the loops for the attachment of the sheath are found on one side, rather than on the edges.

81  We find this technique, for instance, on Carter 267d, the pectoral inlaid with a scarab carved from Libyan Desert Glass (see note 41).

However, we know of no other object from the burial equipment with an identical motif. Within the framework of this contribution, it was impossible to conduct a detailed comparative study on this specific design group.

82　For a representative sample of depictions showing the different ways of wearing this type of dagger, see Petschel 2011, 215–19.

83　Edwards, likewise, states that the sheath was produced in Egypt, but he does not provide any reasons for this hypothesis. However, he refers to several different elements of the depiction as "artistic features which have a foreign appearance" (Edwards 1972, catalogue no. 36). Based on the fact that the animals were not placed exactly one on top of the other and that some of their hooves project into the frame, Petschel assumes that several molds (or forms) of animal motifs of varying sizes were used to produce the scene. She notes that molds would have been easier and safer to transport than chased gold sheets, and concludes that these might simply have been imported rather than produced by Mycenaean–Minoan craftsmen in Egypt (Petschel 2011, 215). However, the use of imported molds to make the repoussé work would not explain the depiction of the rosette on the shoulder of the lion (sometimes called a typically Near Eastern motif, see fig. 44b and page xii), since it was chased into the surface in a second step—i.e. after the chasing (repoussé) of the scene as a whole—and therefore does not relate to the potential use of a mold. She does not discuss alternative production scenarios. For further literature on foreign influences and the question of how they blend into the decoration of the gold sheath, see Petschel 2011, note 605. Be that as it may, only elements from the Egyptian repertoire of motifs were used in the decoration of the other sheath (see fig. 26).

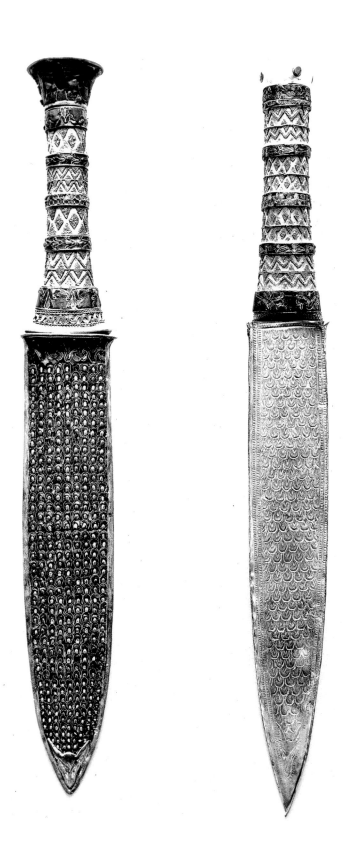

# Bibliography

Adam-Velini, P. 1988. "First report on a new Hellenistic town in West Macedonia." In: *Praktika tou XII Diethnous Synedriou Klasikēs Archaiologias*, Athēna, 4–10 Septembriou 1983 (Athens: Hypourgeion Politismou kai Epistēmōn) 39.

Aitchison, L. 1960. *A History of Metals* (London: MacDonald & Evans).

Amborn, H. 1976. *Die Bedeutung der Kulturen des Niltals für die Eisenproduktion im subsaharischen Afrika*. Studien zur Kulturkunde 39 (Wiesbaden: Franz Steiner).

Andrews, C. 1994. *Amulets of Ancient Egypt* (London: British Museum Press).

Assmann, J. 2001. *Tod und Jenseits im Alten Ägypten* (Munich: C.H. Beck).

Aston, B., J. Harrel, and I. Shaw. 2000. "Stone." In: P.T. Nicholson and I. Shaw (eds.), *Ancient Egyptian Materials and Technology* (Cambridge: Cambridge University Press) 5–77.

Bailleul-LeSuer, R. (ed.). 2012. *Between Heaven and Earth: Birds in Ancient Egypt* [exhibition catalog]. Oriental Institute Museum Publications 35 (Chicago, IL: Oriental Institute of the University of Chicago).

Beinlich, H. 2006. "Zwischen Tod und Grab: Tutanchamun und das Begräbnisritual." *Studien zur Altägyptischen Kultur* 34: 17–31.

Bjorkman, J.K. 1973. "Meteors and Meteorites in the Ancient Near East." *Meteoritics* 8/2: 91–132.

Bongioanni, A, and M. Croce, eds. 2003. *The Treasures of Ancient Egypt: From the Egyptian Museum in Cairo* (New York: Rizzoli).

Bonnet, H. 1952. *Reallexikon der ägyptischen Religionsgeschichte* (Berlin: De Gruyter).

Brandstätter, F., L. Ferrière, and Ch. Köberl. 2012. *Meteoriten—Zeitzeugen der Entstehung des Sonnensystems / Meteorites—Witnesses of the Origin of the Solar System* (Vienna: Naturhistorisches Museum Wien).

Brepohl, E. 2008. *Theorie und Praxis des Goldschmieds* (Leipzig: VEB Fachbuchverlag).

Bridgestock, L.J., H. Williams, M. Rehkämper, F. Larner, M.D. Giscard, S. Hammond, B. Coles, R. Andreasen, B.J. Wood, K.J. Theiss, C.L. Smith, G.K. Benedix, and M. Schönbechler. 2014. "Unlocking the zinc isotope systematics of iron meteorites." *Earth and Planetary Science Letters* 400: 153–64.

Broschat, K., and Th. Rehren. 2017. "The Glass Headrests of Tutankhamen." *Journal of Glass Studies* 59: 377–80.

Broschat, K., Th. Rehren, and Ch. Eckmann. 2016. "Makelloses Flickwerk – Die gläsernen Kopfstützen des Tutanchamun und Anderes." *Restaurierung und Archäologie* 9: 1–24.

Broschat, K., F. Ströbele, Ch. Koeberl, Ch. Eckmann, and E. Mertah. 2018. *Himmlisch! Die Eisenobjekte aus dem Grab des Tutanchamun.* (Mainz: Verlag des Römisch-Germanischen Zentralmuseums).

Brunon, G. 1935. "Pesesh kef amulets." *Annales du Service des Antiquités de l'Égypte* 35: 213–17.

Buchwald, V.F. 1975. *Handbook of Iron Meteorites. Their History, Distribution, Composition and Structure* 1–3 (Tempe, AZ: Arizona State University, Center for Meteorite Studies; Berkeley, CA: University of California Press), https://evols.library.manoa.hawaii.edu/handle/10524/33750.

———. 1992. "On the Use of Iron by the Eskimos in Greenland." *Materials Characterization* 29/2: 139–76.

———. 2005. *Iron and steel in ancient times*. Historisk-filosofiske skrifter 29 (Copenhagen: Det Kongelige Danske Videnskabernes Selskab).

Campbell, A.J., and M. Humayun. 2007. "Composition of group IVB iron meteorites and their parent melt." *Geochimica et Cosmochimica Acta* 69/19: 4733–44.

Carter, H. 1927. *The Tomb of Tut Ankh Amen. Discovered by the Late Earl of Carnarvon and Howard Carter II* (London, Toronto, Melbourne: Cassell & Co. Ltd).

———. 1933. *The Tomb of Tut Ankh Amen. Discovered by the Late Earl of Carnarvon and Howard Carter III* (London, Toronto, Melbourne: Cassell & Co. Ltd ).

Carter, H., and A.C. Mace. 1923. *The Tomb of Tut Ankh Amen. Discovered by the Late Earl of Carnarvon and Howard Carter I* (London, Toronto, Melbourne: Cassell & Co. Ltd).

Clark, R. 2003. *The Sacred Magic of Ancient Egypt: The Spiritual Practice Restored* (St. Paul, MN: Llewellyn Publications).

Comelli, D., M. D'Orazio, L. Folco, M. El-Halwagy, T. Frizzi, R. Alberti, V. Capogrosso, A. Elnaggar, H. Hassan, A. Nevin, F. Porcelli, M. G. Rashed, and G. Valentini. 2016. "The meteoritic origin of Tutankhamun's iron dagger blade." *Meteoritics & Planetary Science* 51/7: 1301–309.

Davies, N.M. 1936. *Ancient Egyptian Paintings II* (Chicago, IL: University of Chicago Press).

Desroches-Noblecourt, Ch. 1963. *Tutankhamen: Life and Death of a Pharaoh* (London: The Connoisseur and Michael Joseph).

———. 2003. *Lorsque la nature parlait aux Égyptiens* (Paris: Rey).

D'Orazio, M, L. Foloco, A. Zeoli, and C. Cordier. 2011. "Gebel Kamil: The iron meteorite that formed the Kamil Crater (Egypt)." *Meteoritics & Planetary Science* 46/8: 1179–96.

Eaton-Krauss, M. 2016. "Tutankhamen's Iron Dagger Made from a Meteorite?" *Kmt. A Modern Journal of Ancient Egypt* 27/1: 30–32.

Eckmann Ch. Forthcoming. *Die Maske – Chronologie einer Ikone.*

Edwards, I.E.S. 1972. *Treasures of Tutankhamun* [exhibition catalog] (London: Thames & Hudson).

Feldmann, M.H. 2006. *Diplomacy by Design. Luxury Arts and an "International Style" in the Ancient Near East, 1400–1200 BCE* (Chicago, IL, London: University of Chicago Press).

Forbes, R.J. 1950. *Metallurgy in Antiquity: A notebook for archaeologists and technologists* (Leiden: Brill).

Frantz, J.H. and D. Schorsch. 1990. "Egyptian Red Gold." *Archaeomaterials* 4: 133–52.

Graefe, E. 1971. "Untersuchungen zur Wortfamilie bj3-." Unpublished dissertation, University of Cologne.

Graf, F. 2012. *Der ägyptische Glaube. III: Ägyptische Amulette, Perlen, Mythologie und das alltägliche Leben* (Norderstedt: Books on Demand GmbH).

Hayes, W.C. 1959. *The Scepter of Egypt. A Background for the Study of Egyptian Antiquities in the Metropolitan Museum of Art. II: The Hyksos Period and the New Kingdom (1675–1080 B.C.)* (Cambridge, MA: Harvard University Press).

Heinrich, Th. A. 1963. *Art Treasures in the Royal Ontario Museum* (Toronto: McClelland and Stewart).

Helck, W. 1975. *Wirtschaftsgeschichte des Alten Ägypten im 3. und 2. Jahrtausend vor Chr. Handbuch der Orientalistik Abt. 1. Der Nahe und Mittlere Osten, Bd. 1, Abschnitt 5* (Leiden, Cologne: E.J. Brill).

Hellinckx, B.R. 1997. "Tutankhamun's Carnelian Swallow with Sun Disc: Part of a Garment?" *Journal of Egyptian Archaeology* 83: 109-25.

Helmi, F., and K. Barakat. 1995. "Micro analysis of Tutankhamun's Dagger." In: F.A. Esmael (ed), *Proceedings of the First International Conference on Ancient Egyptian Mining & Metallurgy and Conservation of Metallic Artifacts, Cairo* (Cairo: Egyptian Antiquities Organization Press) 287–89.

Jambon, A. 2017. "Bronze Age iron: Meteoritic or not? A chemical strategy." *Journal of Archaeological Science* 88: 47–53.

Jochum, K.P., M. Seuffert, and F. Begemann. 1980. "On the distribution of major and trace elements between metal and phosphide phases of some iron meteorites." *Zeitschrift für Naturforschung* 35a: 57–63.

Johnson, D., and J. Tyldesley. 2016. "Iron from the sky: the role of meteorite iron in the development of iron-working techniques in ancient Egypt." In: C. Price, R. Forshaw, A. Chamberlain, and P.T. Nicholson (eds.), *Mummies, magic and medicine in ancient Egypt. Multidisciplinary*

*essays in honour of Rosalie David* (Manchester: Manchester University Press) 408–23.

Johnson, D., J. Tyldesley, T. Lowe, Ph. J. Withers, and M.M. Grady. 2013. "Analysis of a prehistoric Egyptian iron bead with implications for the use and perception of meteorite iron in ancient Egypt." *Meteoritics & Planetary Science* 48: 997–1006.

Koşay, H.Z. 1938. *Türk Tarih Kurumu tarafından yapılan Alaca Höyük hafriyatı: 1936 daki çalışmalara çalışmalara ve keşiflere ait ilk rapor* (Ankara: Türk Tarih Kurumu Basımevi).

Kracher, A., J. Willis, and J.T. Wasson. 1980. "Chemical Classification of Iron Meteorites-IX. A New Group (IIF), Revision of IAB and IIICD, and Data on 57 Additional Irons." *Geochimica et Cosmochimica Acta* 44/6: 773–87.

von Lieven, A. 2007. *Grundriss des Laufes der Sterne: das sogenannte Nutbuch*. The Carlsberg Papyri 8, CNI Publications 31 (Copenhagen: Museum Tusculanums Forlag).

Lilyquist, C. 1993. "Granulation and Glass: Chronological and Stylistic Investigations at Selected Sites, ca. 2500–1400 B.C.E." *Bulletin of the American Schools of Oriental Research* 290/29: 29–94.

Lorenzen, J. 1882. "Kemisk undersøgelse af det metalliske jern fra Grønland." *Meddelelser om Grønland* 4: 1–40.

Lucas, A. and J.R. Harris. 1962. *Ancient Egyptian Materials and Industries* (London: Edward Arnold & Co.).

Nakai, I., Y. Abe, K. Tantrakarn, S. Omura, and S. Erkut. 2008. "Preliminary Report on the Analysis of an Early Bronze Age Dagger Excavated from Alacahöyük." *Anatolian Archaeological Studies* XVII: 321–23.

Neumann, J.G. 1848. "Über die kristallinische Struktur des Meteoreisens von Braunau." *Naturwissenschaftliche Abhandlungen Wien* 3: 45–56.

Maxwell-Hyslop, K.R. 1972. "The Metals amutu and asi'u in the Kültepe Texts." *Anatolian Studies* 22: 159–62.

Merkel, J., and K. Barrett. 2000. "'The adventitious production of iron in the smelting of copper' revisited: metallographic evidence against a tempting model." *Historical Metallurgy* 34/4: 59–66.

de Michele, V. 1998. "The 'Libyan Desert Glass' scarab in Tutankhamen's pectoral." *Sahara: preistoria e storia del Sahara* 10: 107–109.

Müller-Winkler, C. 1987. *Die ägyptischen Objekt-Amulette. Mit Publikation der Sammlung des Biblischen Instituts der Universität Freiburg Schweiz, ehemals Sammlung Fouad S. Matouk*. Orbis biblicus et orientalis: Series archaeologica 5 (Fribourg; Göttingen: Universitätsverlag; Vandenhoeck & Ruprecht).

Oddy, A. 1977. "The production of gold wire in antiquity." *Gold Bulletin* 10/3: 79–87.

Ogden, J. 2000. "Metals." In: P.T. Nicholson and I. Shaw (eds.), *Ancient Egyptian Materials and Technology* (Cambridge: Cambridge University Press) 148–76.

Otto, E. 1960. *Das ägyptische Mundöffnungsritual*. Ägyptologische Abhandlungen 3 (Wiesbaden: Harrassowitz).

Pare, Ch. 2017. "Frühes Eisen in Südeuropa: Die Ausbreitung einer technologischen Innovation am Übergang vom 2. zum 1. Jahrtausend v. Chr." In: E. Miroššayová, Ch. Pare, and S. Stegmann-Rajtár (eds.), *Das nördliche Karpatenbecken in der Hallstattzeit. Wirtschaft, Handel und Kommunikation in früheisenzeitlichen Gesellschaften zwischen Ostalpen und Westpannonien*. Archaeolingua 38 (Budapest: Archaeolingua) 11–116.

Patch, D.C. 1995. "A 'Lower Egyptian' Costume: Its Origin, Development, and Meaning." *Journal of the American Research Center in Egypt* 32: 93–116.

Petschel, S. 2011. *Den Dolch betreffend—Typologie der Stichwaffen in Ägypten von der prädynastischen Zeit bis zur 3. Zwischenzeit*. Philippika 36 (Wiesbaden: Harrassowitz).

Photos, E. 1989. "The Question of Meteoritic versus Smelted Nickel-Rich Iron: Archaeological Evidence and Experimental Results." *World Archaeology* 20/3: 403–21.

Rainey, A.F. 2015. *The El-Amarna Correspondence. A New Edition of the Cuneiform Letters from the Site of El-Amarna based on Collations of all Extant Tablets* 1. Handbuch der Orientalistik. Abt. 1. The Near and Middle East, vol. 110 (Leiden, Boston, MA: Brill).

Rapp, G. 2009. *Archaeomineralogy* (Berlin, Heidelberg: Springer).

Rasmussen, K.L., D.J. Malvin, V.F. Buchwald, and J.. Wasson. 1984. "Compositional trends and cooling rates of group IVB iron meteorites." *Geochimica et Cosmochimica Acta* 48/4: 805–13.

Rehren, Th., T. Belgya, A. Jambon, G. Káli, Z. Kasztovszky, Z. Kis, I. Kovács, B. Maróti, M. Martinón-Torres, G. Miniaci, V.C. Pigott, M. Radivojević, L. Rosta, L. Szentmiklósi, and Z. Szőkefalvi-Nagy. 2013. "5,000 years old Egyptian iron beads made from hammered meteoritic iron." *Journal of Archaeological Science* 40: 4785–92.

Reisner, G.A. 1923. *Excavations at Kerma 45*. Harvard African Studies 6 (Cambridge, MA: Peabody Museum of Harvard University).

Reiter, K. 1997. *Die Metalle im Alten Orient. Unter besonderer Berücksichtigung altbabylonischer Quellen*. Alter Orient und Altes Testament 249 (Münster: Ugarit-Verlag).

Roberts, B.W., Ch.P. Thornton, and V.C. Pigott. 2009. "Development of metallurgy in Eurasia." *Antiquity* 83: 1012–22.

Roth, A.M. 2005. "Cat.no. 1, Grips from a Dagger Handle of Thutmose I." In: C.H. Roehrig (ed.), *Hatshepsut: From Queen to Pharaoh* [exhibition catalog: San Francisco,CA; New York, NY; Fort Worth, TX] (New York: Metropolitan Museum of Art) 15.

Rudnitzky, G. 1956. *Die Aussage über "Das Auge des Horus". Eine altägyptische Art geistiger Äußerung nach dem Zeugnis des Alten Reiches*. Analecta Aegyptiaca 5 (Copenhagen: Ejnar Munksgaard).

Saretta, P. 2016. *Asiatics in Middle Kingdom Egypt. Perceptions and Reality* (London: Bloomsbury Academic).

Scalf, F. 2017. *Book of the Dead: Becoming God in Ancient Egypt*. Oriental Institute Museum Publications 39 (Chicago, IL: The Oriental Institute of the University of Chicago).

Schäfer, H. 1963. *Von ägyptischer Kunst. Eine Grundlage* (Wiesbaden: Otto Harrassowitz).

Shalev, S. 2004. *Swords and Daggers in Late Bronze Age Canaan*. Prähistorische Bronzefunde IV 13 (Stuttgart: F. Steiner).

Shortland, A. 2012. *Lapis Lazuli from the Kiln. Glass and Glassmaking in the Late Bronze Age*. Studies in Archaeological Sciences 2 (Leuven: Leuven University Press).

Siegelova, J. 1984. "Gewinnung und Verarbeitung von Eisen im hethitischen Reich im 2. Jahrtausend v. u. Z." *Annals of the Náprstek Museum* 12: 71–178.

Sighinolfi, G.P., E. Sibilia, G. Contini, and M. Martini. 2015. "Thermoluminescence dating of the Kamil impact crater (Egypt)." *Meteoritics & Planetary Science* 50/2: 204–13.

Stevenson, A. 2009. "Social relationships in Predynastic burials." *Journal of Egyptian Archaeology* 95: 175–92.

Ströbele, F., K. Broschat, C. Koeberl, J. Zipfel, H. Hassan, and Ch. Eckmann. 2016a. "Meteoritic Origin of a Dagger among the Iron Objects of Tutanchamun." In: *79th Annual Meeting of the Meteoritical Society* (n.p.p.), abstract 6508.

———. 2016b. "The Iron Objects of Tutanchamun." In: S. Greiff, A. Kronz, F. Schlüter, and M. Prange (eds.), *Archäometrie und Denkmalpflege 2016. Jahrestagung an der Georg-August-Universität Göttingen, 28. September bis 1. Oktober 2016*. Metalla Sonderheft 8 (Bochum: Deutsches Bergbau-Museum) 186–89.

Vogelsang-Eastwood, G. 1993. *Pharaonic Egyptian Clothing. Studies in Textile and Costume History* 2 (Leiden, New York, NY: E.J. Brill).

Wainwright, G.A. 1932. "Iron in Egypt." *Journal of Egyptian Archaeology* 18: 3–15.

Wasson, J.T., H. Huber, and D.J. Malvin. 2007. "Formation of IIAB iron meteorites." *Geochimica et Cosmochimica Acta* 71: 760–81.

Wilde, H. 2011. *Innovation und Tradition. Zur Herstellung und Verwendung von Prestigegütern im pharaonischen Ägypten*. Göttinger Orientforschungen: IV. Reihe, Bd. 49 (Wiesbaden: Harrassowitz)

———. 2013. "Technologie und Kommunikation. Innovationsschübe vor dem Hintergrund der Außenbeziehungen Altägyptens." In: E. Kaiser and W. Schier (eds.), *Mobilität und Wissenstransfer in diachroner und interdisziplinärer Perspektive*. Topoi 9 (Berlin, Boston, MA: De Gruyter) 115–50.

Wilsdorf, H. 1954. "Historische und archäologische Quellen zur Geschichte des Eisens." In: B. Neumann (ed.), *Die ältesten Verfahren der Erzeugung technischen Eisens durch direkte Reduktion von Erzen mit Holzkohle in Rennfeuern und Stücköfen und die Stahlerzeugung unmittelbar aus dem Eisenerz.* Freiberger Forschungshefte D6 (Berlin: Akademie Verlag Berlin) 67–90.

Woermann, K. 1905. *Geschichte der Kunst aller Zeiten und Völker. 2: Die Kunst der Naturvölker und der übrigen nichtchristlichen Kulturvölker* (Vienna, Leipzig: Bibliographisches Institut).

Wohlfarth, S. 2005. "Grabbeigaben im Flachbild der Privatgräber des Neuen Reiches. Versuch einer ikonographischen und kompositionellen Bestimmung." Dissertation, University of Munich, https://edoc.ub.uni-muenchen.de/3188/ [The PDF itself is found here: https://edoc.ub.uni-muenchen.de/3188/1/Wohlfarth_Susanne.pdf]

Wolters, J. 1983. *Die Granulation – Geschichte und Technik einer alten Goldschmiedekunst* (Munich: Callwey).

———. 1985. "Filigran (Filigranarbeiten, Filigrandraht)." https://www.rdklabor.de/wiki/Filigran_(Filigranarbeiten,_Filigrandraht).

———. 2014. "Granulation." https://www.rdklabor.de/wiki/Granulation.

Yalçin, Ü. 2005. "Zum Eisen der Hethiter." In: Ü. Yalçin, C. Pulak, and R. Slotta. *Das Schiff von Uluburun—Welthandel vor 3000 Jahren* [exhibition catalog]. Veröffentlichungen aus dem Deutschen Bergbau-Museum Bochum 138 (Bochum: Deutsches Bergbau-Museum) 493–502.

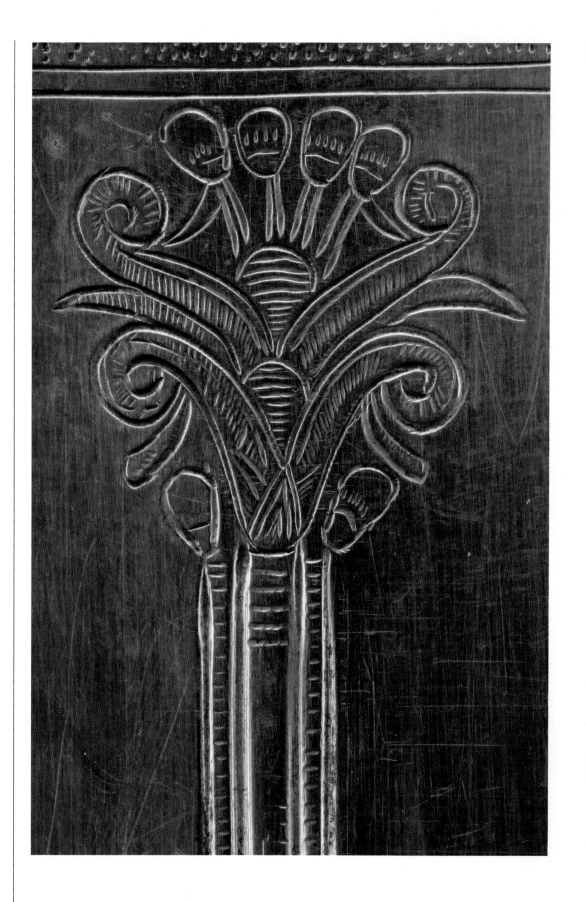